HOW TO DRAW
CARTOON
ANIMALS

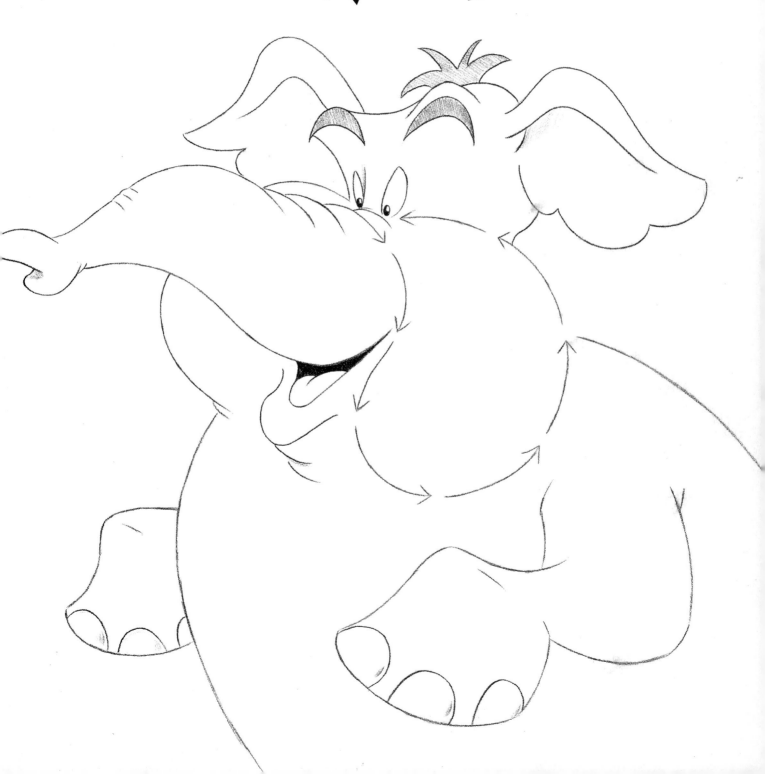

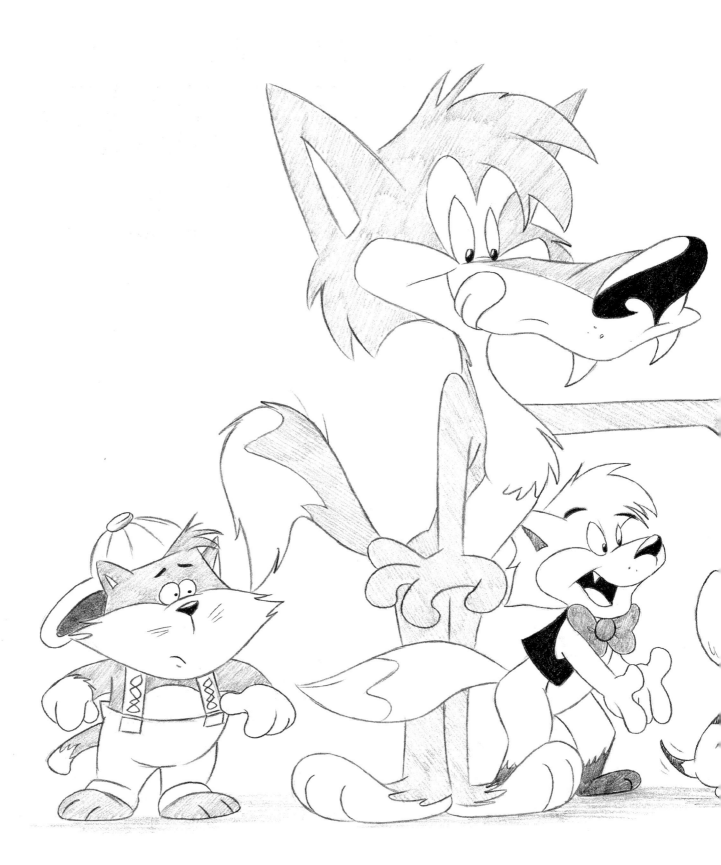

HOW TO DRAW
CARTOON
ANiMALs

Christopher Hart

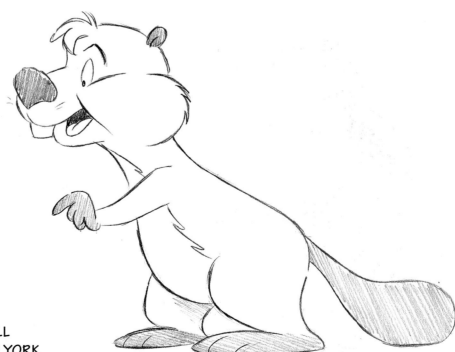

WATSON-GUPTILL
PUBLICATIONS/ NEW YORK

Dedicated to everybody who loves to draw cartoons.

ACKNOWLEDGMENTS
I'd like to thank everyone at Watson-Guptill Publications
for their support of our projects together.

Senior Editor: Candace Raney
Associate Editor: Dale Ramsey
Designer: Bob Fillie, Graphiti Graphics
Production Manager: Hector Campbell

First published in 1995 by Watson-Guptill Publications,
Crown Publishing Group,a division of Random House Inc.,New York
www. crownpublishing.com
www.watsonguptill.com

ISBN-13: 978-0-8230-2360-8
ISBN-10: 0-8230-2360-5

Distributed in the United Kingdom by Phaidon Press, Ltd.,
2 Kensington Square, London W8 5EZ, England

Distributed in Europe (except the United Kingdom), South and Central
America, the Caribbean, the Far East, the Southeast, and Central Asia
by Rotovision S.A., Route Suisse 9, CH-1295 Mies, Switzerland.

Printed in China

First printing, 1995

18 / 12 11 10 09

Christopher Hart is the best-selling author of Watson-Guptill's most popular how-to-draw books covering everything from cartooning to animation, and comic strips to comic books. His books have been translated into 10 languages, and he is a guest writer for *Cartoonist Profiles,* a trade magazine. Hart began his career in animation working as a character designer for an animation studio while still in high school. He attended the Disney character animation program at The California Institute of the Arts and then went on to earn his B.A. at New York University's Film School. Following that, he furthered his studies at The School of Visual Arts and The Paier College of Art.

Hart worked on the staff of the world famous *Blondie* comic strip and has been a regular contributor to *Mad Magazine.* His work has also appeared in numerous magazines, such as the popular *Highlights for Children, Crayola Kids,* and The National Wildlife Federation's *Ranger Rick.* He has been a member of The National Cartoonists Society, ASIFA (The International Animation Society), and the Writer's Guild of America.

In addition to his work in cartooning, Hart has written comedies for many of the top film and television studios, including MGM, Paramount, Fox, NBC, and the Showtime Cable Television Network. He lives in Connecticut with his wife and daughters.

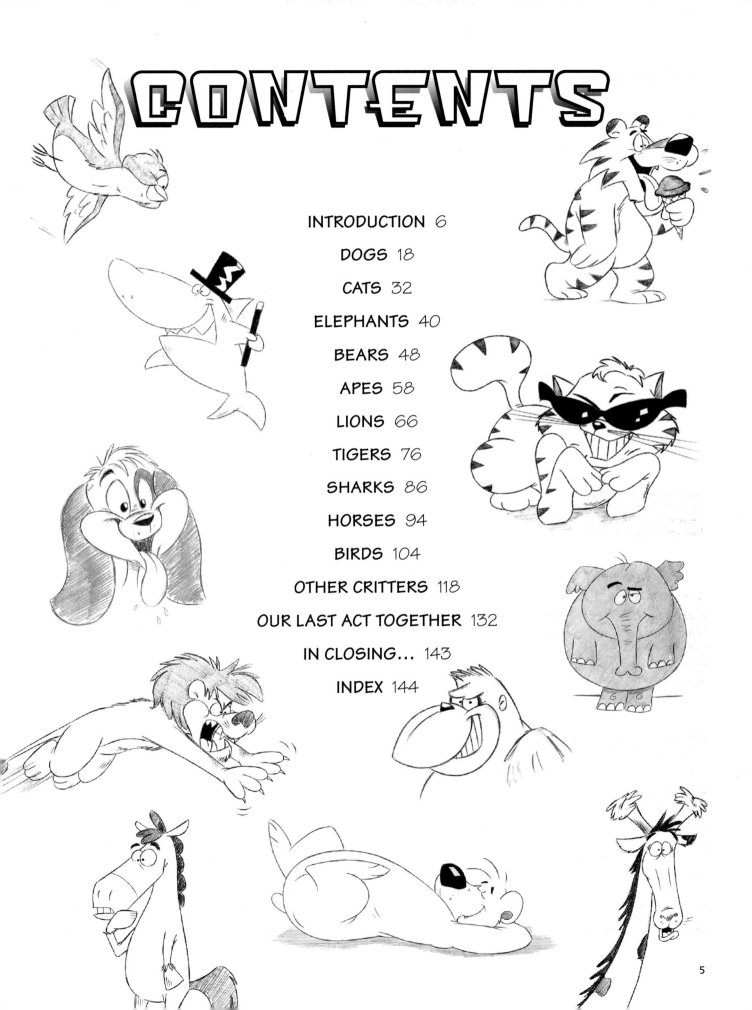

CONTENTS

5

INTRODUCTION

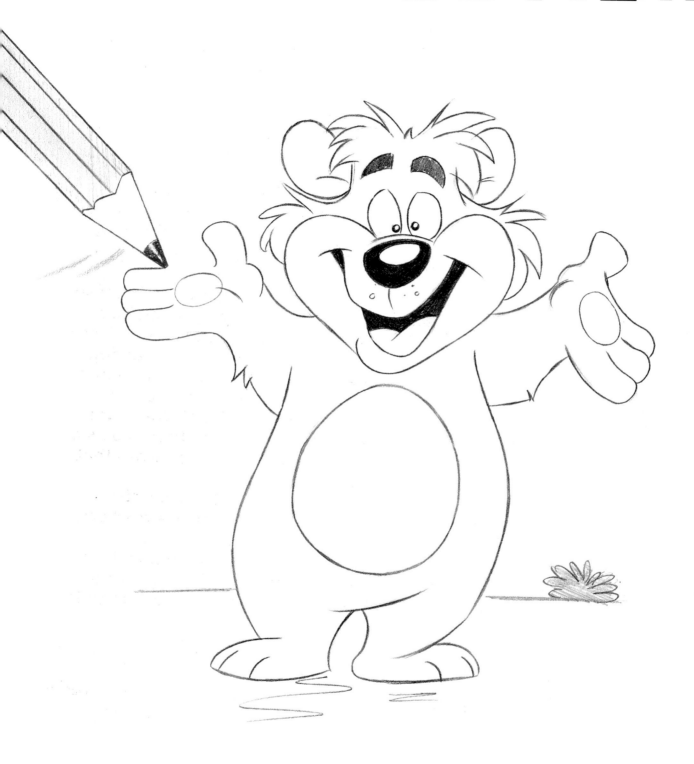

For the aspiring cartoonist, as well as for those already in the profession, it is useful to ask the question: What are the most popular cartoon characters? Those that represent animals are clearly the favorites. The world's most famous cartoon character is a mouse. Who is more popular, Bugs Bunny or Elmer Fudd? Garfield or Jon? The animals are the stars. Even in comic strips where humans are featured, animal characters are essential. Calvin wouldn't be Calvin without Hobbes. Often, Charlie Brown yields center stage to Snoopy.

The fact is, if you want to draw cartoons, you need to know how to draw many different types of cartoon animals. And that is what this book is designed to help you do. We will cover most of the animals you will need to draw as a cartoonist. The most popular ones are given the greatest attention.

Each animal begins with a simple approach that anyone can master with a little practice. Further approaches are then explored which are designed to give you the tools you need to design your own animal characters.

You will also learn the rules of cartoonland—for instance: when a dog is a pet, and when it is the master. Certain species are typecast in humorous roles. I will show you how to give specific animals their appropriate cartoon personalities.

This book is designed for those interested in cartooning, comic strips, children's illustration, advertising, and film animation. All these related fields rely on the animal kingdom for their subject matter.

Animals are fun to draw because there are so many varieties. You may wish to draw dogs, but which? You can choose from the bulldog, the Doberman, the mutt, or many others. You may want to draw bears. But which kind? There are polar bears, grizzlies, brown bears, and cubs. Each has properties that make it unique.

One thing is certain, whether you are a novice, an intermediate, or a lifelong cartoonist, you will have hours of fun drawing all the creatures that inhabit our world. Best of luck, and now, let's go to it!

C. Hart

WE'LL GO STEP BY STEP

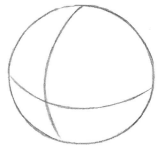

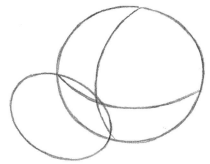

All cartoon characters start with simple, sketchy shapes...

which we build onto . . .

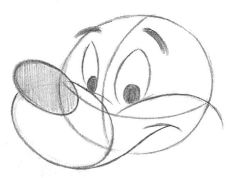

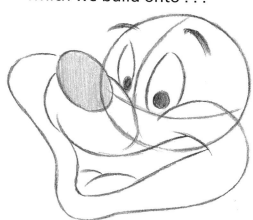

adding detail as we go.

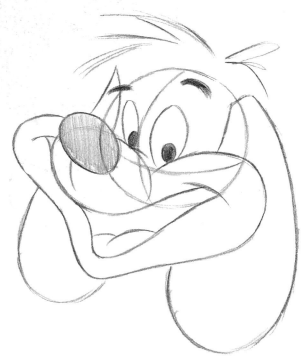

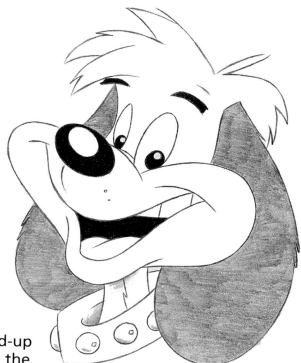

The finished cartoon is a cleaned-up version of the sketchy one, with the addition of a series of final touches.

MOST CARTOON ANIMAL HEADS HAVE THREE BASIC ELEMENTS.

The skull

The snout (or trunk)

And the cheeks or jaw.

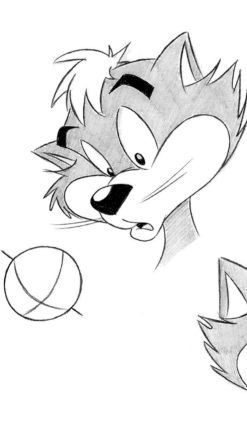

Try to visualize the head as a globe. Tilt the globe to vary the head position. Notice that the far eye in each pose is drawn smaller. This creates the illusion of roundness and depth.

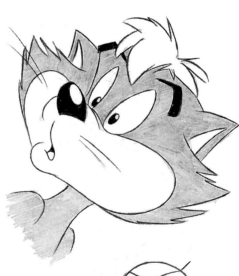

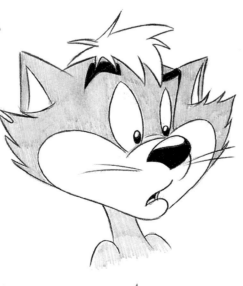

CHARACTER IDENTITY

Animal cartoons should be readily identifiable by their silhouettes. To ensure this, simply exaggerate the most prominent feature—for example, the rabbit's ears, horse's snout, elephant's trunk, alligator's nose, and parrot's beak.

SOLID SHAPES

If you divide a body into its various shapes, you'll see that each individual shape is solid and three-dimensional. The bending occurs between the solid shapes.

BODY ATTITUDES

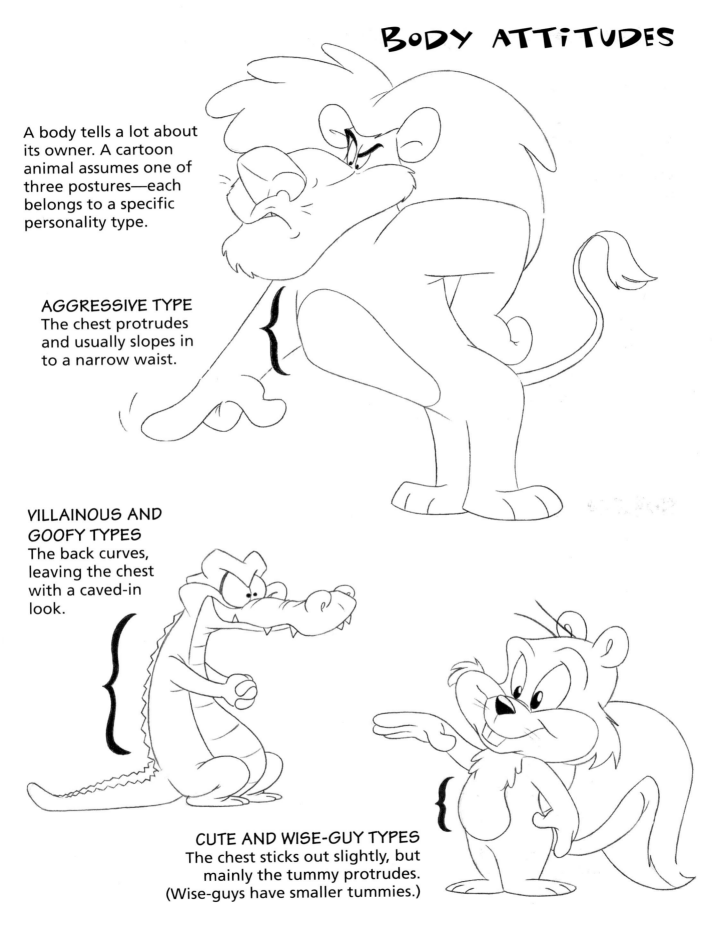

A body tells a lot about its owner. A cartoon animal assumes one of three postures—each belongs to a specific personality type.

AGGRESSIVE TYPE
The chest protrudes and usually slopes in to a narrow waist.

VILLAINOUS AND *GOOFY* TYPES
The back curves, leaving the chest with a caved-in look.

CUTE AND WISE-GUY TYPES
The chest sticks out slightly, but mainly the tummy protrudes. (Wise-guys have smaller tummies.)

MAINTAIN PROPORTIONS

No matter what pose or position you give your
character, its proportions should always remain
the same. Lines drawn at various points on
the body are helpful for checking.

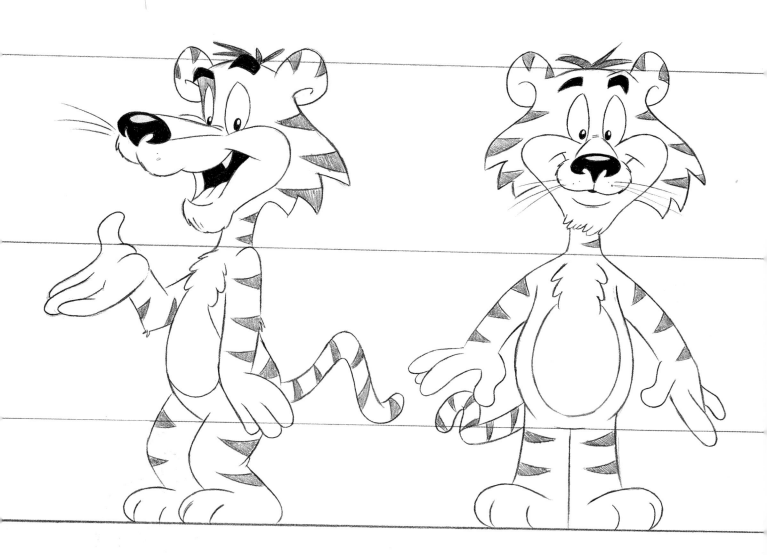

The most common mistake made by beginners is that they draw each line as if etching it in stone. Professional cartoonists start by drawing loose and sketchy. They press lightly on their pencils. This allows the imagination the freedom to experiment.

Once your cartoon takes shape as a sketch, choose the lines you like by drawing those darker and erase the rest. This is called "cleaning up" a rough.

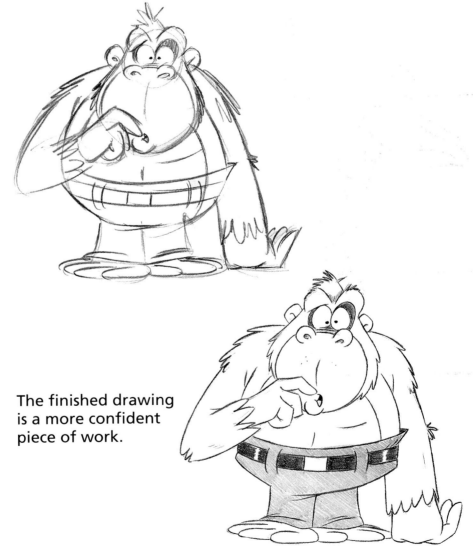

The finished drawing is a more confident piece of work.

DRAW THE LINES YOU WON'T SEE

I'M GIVING AWAY MY **BEST** SECRETS!

If a forearm or a leg is partially hidden from view by the rest of the body, don't try guessing where it should go. Instead, draw the entire limb from its point of origin. Then erase the parts that overlap.

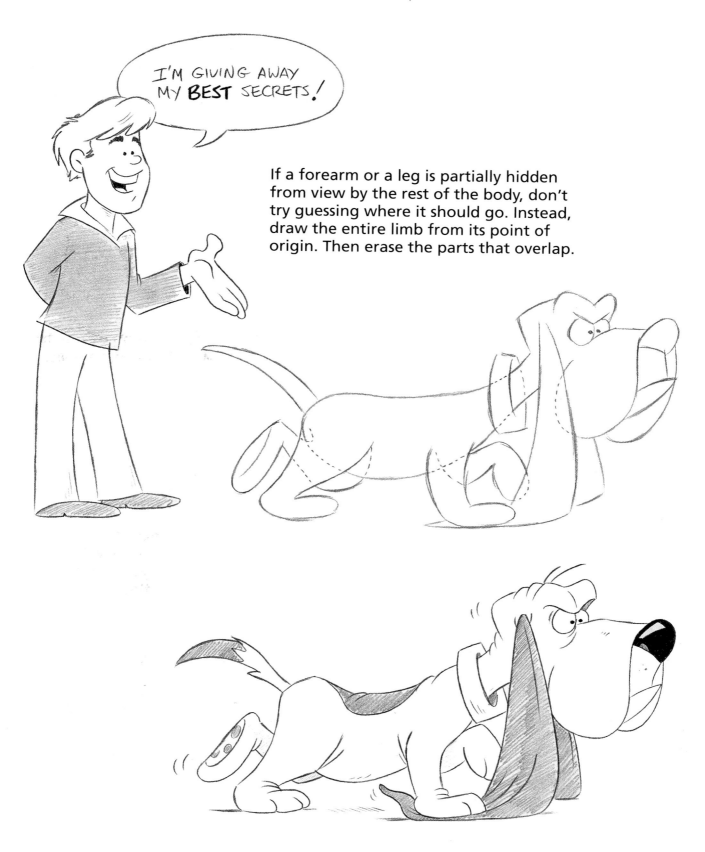

THE ACTION LINE

The action line is an imaginary line, used as a guide, that conveys the direction of a pose. The action line is the foundation of every pose, whether a character is leaping in the air or just leaning against a tree.

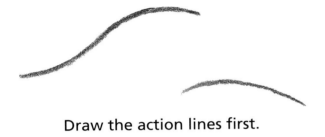

Draw the action lines first.

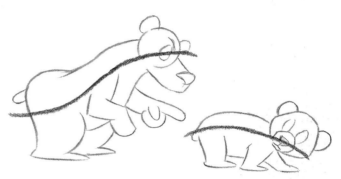

Then sketch the bodies, being careful to maintain the sweep of the action lines.

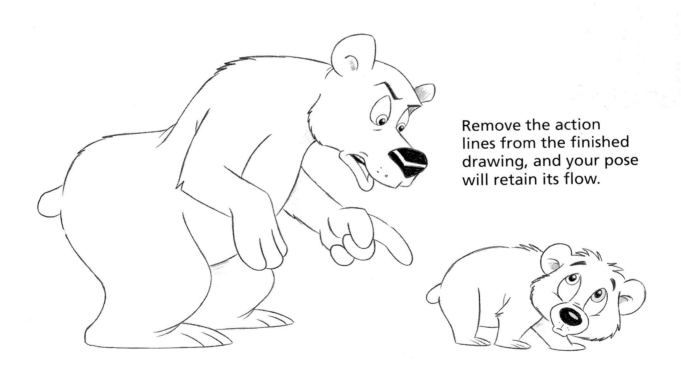

Remove the action lines from the finished drawing, and your pose will retain its flow.

AN ACTION LINE IS HIDDEN IN EVERY GOOD POSE.

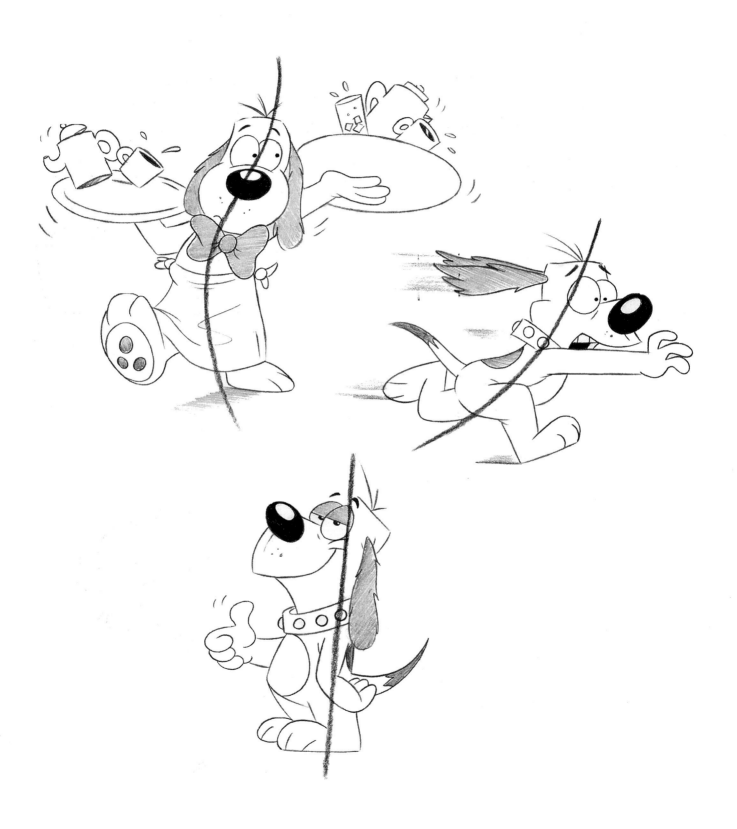

ACTION/REACTION

When a cartoon character thrusts its weight in one direction, another part of the body must compensate by moving in the opposite direction. This serves to maintain balance.

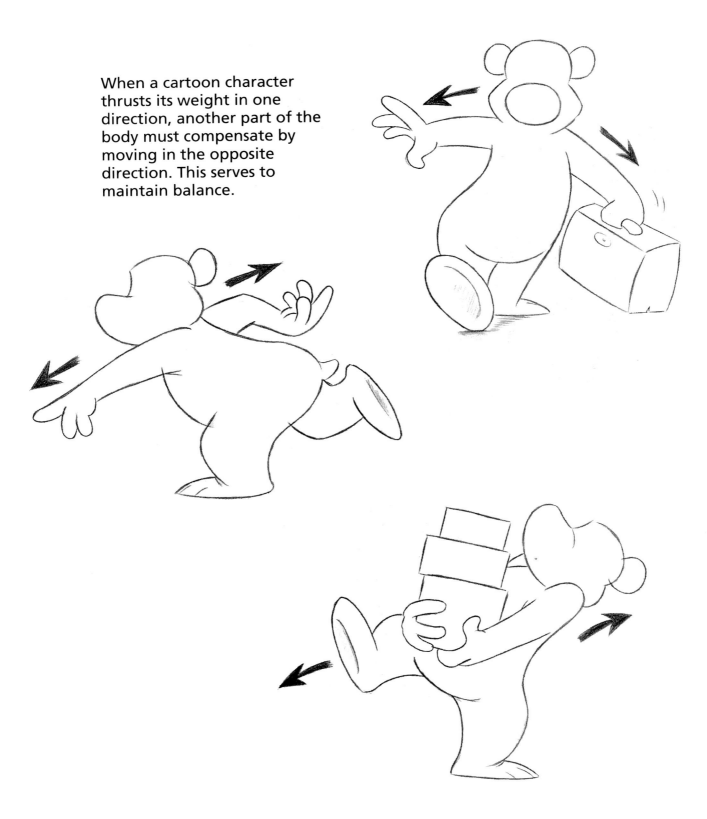

The simplest cartoon dog has a head based on two elements:
The skull and the jaw. The nose sort of "floats" in the jaw section.

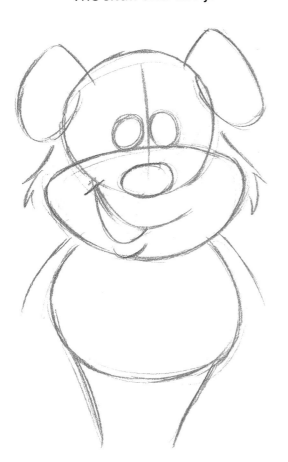

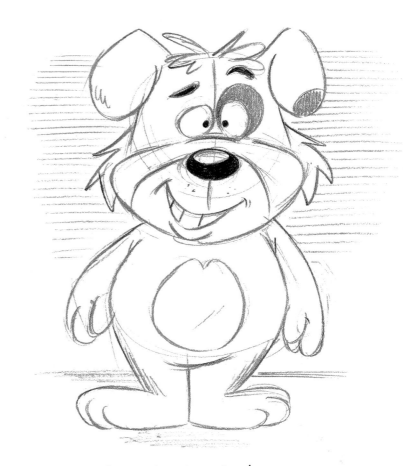

A dog that walks on two legs, like a person, is the easiest type to draw.
It is as common in comic strips and animation as the four-legged variety.
As a professional cartoonist, you would be called on to draw it both ways.

DOG HEADS

For most dog heads you will want to employ a more advanced construction built on three elements: The skull, the jaw, and the snout. The nose is firmly embedded in the snout.

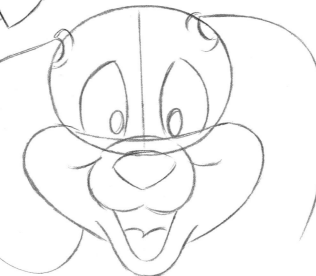

Notice how the line that forms the snout curves around to become the mouth.

Markings are important features of dog cartoons. Mark your dog boldly. This dog has symmetrically opposite black and white markings. The side of the face that is white has a black ear.

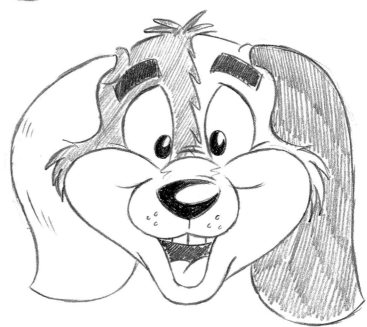

THE FAMOUS "HEAD TILT"

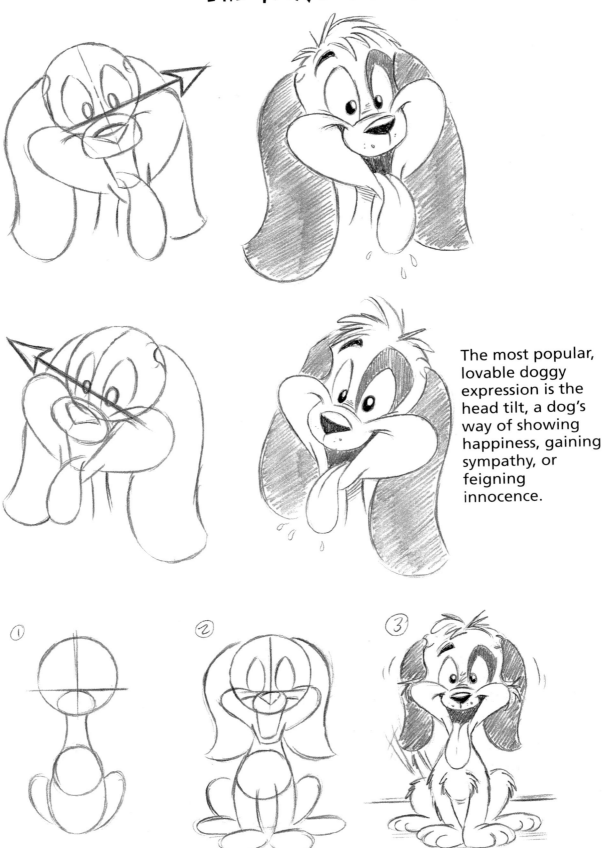

The most popular, lovable doggy expression is the head tilt, a dog's way of showing happiness, gaining sympathy, or feigning innocence.

DOG ANATOMY

REAL DOGS
At first glance, the real dog's legs and forelegs appear to have joints that are different from human folks'. Not so. Theirs are just spaced differently.

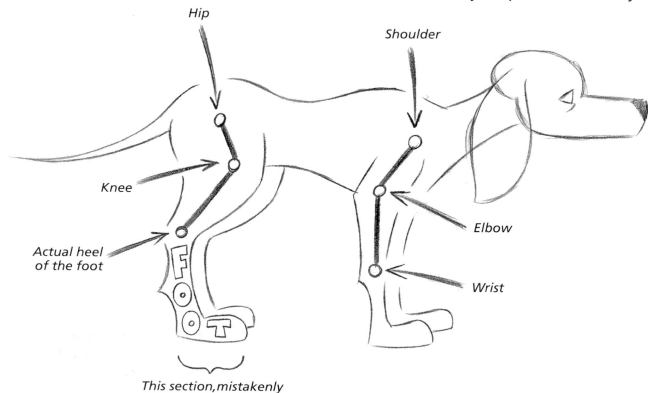

Hip

Shoulder

Knee

Elbow

Actual heel of the foot

Wrist

FOOT

This section, mistakenly thought of as the dog's foot, is actually only its toes

CARTOON DOGS
Simplify the rear legs. Leave the elbow joint in the forelegs but eliminate the wrist joint.

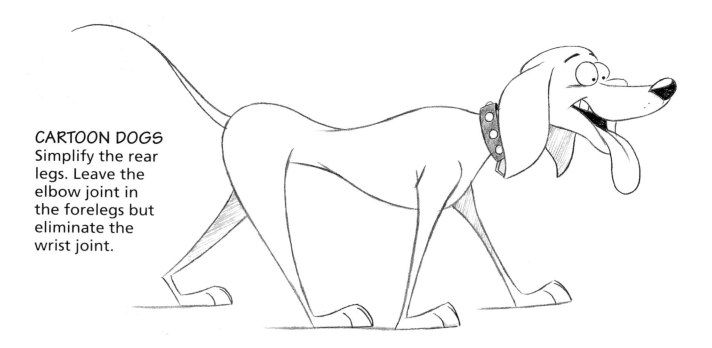

DOGS iN ACTiON

The smaller the dog,
the bigger the head in
proportion to the body.

In drawing action poses, it is especially
important to rough in only the general
parts before filling in the details.

CHOMP!

The shadow is necessary to show just how
far off the ground the dog is leaping.

BEGGING

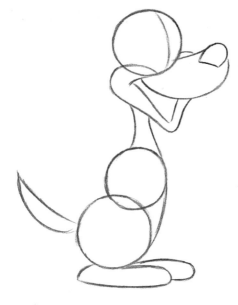

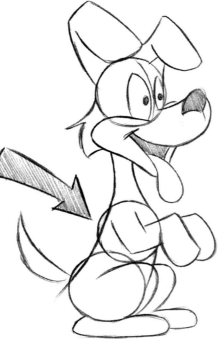

The arch of the back is important to this pose. To emphasize this, a line can be drawn which cuts off part of the circle, giving a greater sweep to the back.

Eyes up, paws out

FOLLOWING A SCENT

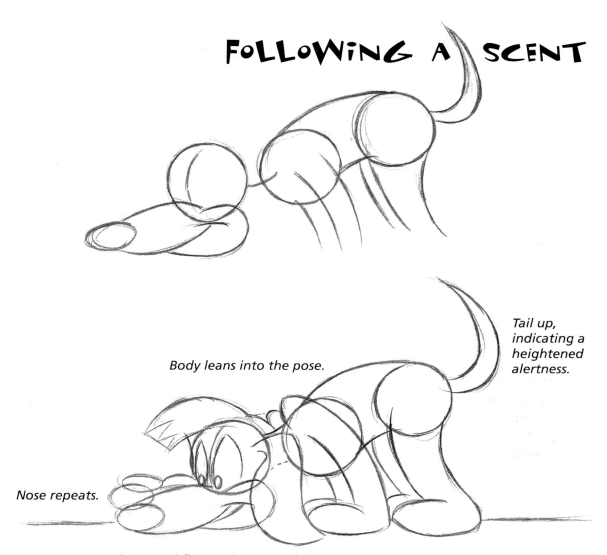

Body leans into the pose.

Tail up, indicating a heightened alertness.

Nose repeats.

Mouth pressed flat on the ground.

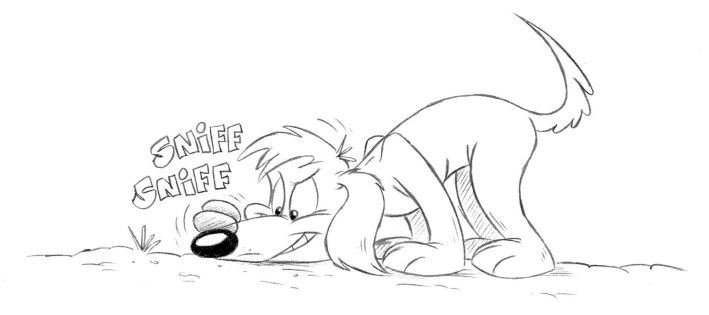

SNIFF
SNIFF

DALMATIANS

These dogs are famous for their uneven black spots on a white coat. The ears can be spotted too, but I prefer to blacken them to add contrast with the rest of the head.

Bright-eyed and eager!

No ruffled hair

Floppy ears

Slender chin

Thick neck

The mouth can get very small in quizzical expressions.

The greyhound-type body has an arched back and legs that narrow to tiny feet.

BULLDOG

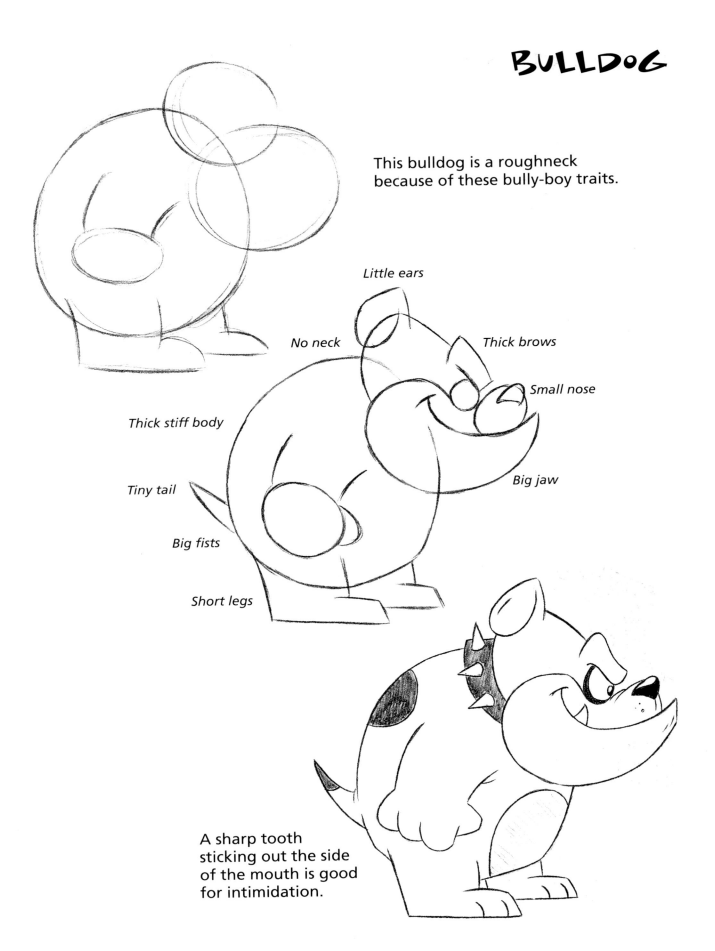

This bulldog is a roughneck because of these bully-boy traits.

Little ears

No neck

Thick brows

Small nose

Thick stiff body

Tiny tail

Big fists

Short legs

Big jaw

A sharp tooth sticking out the side of the mouth is good for intimidation.

Mutts

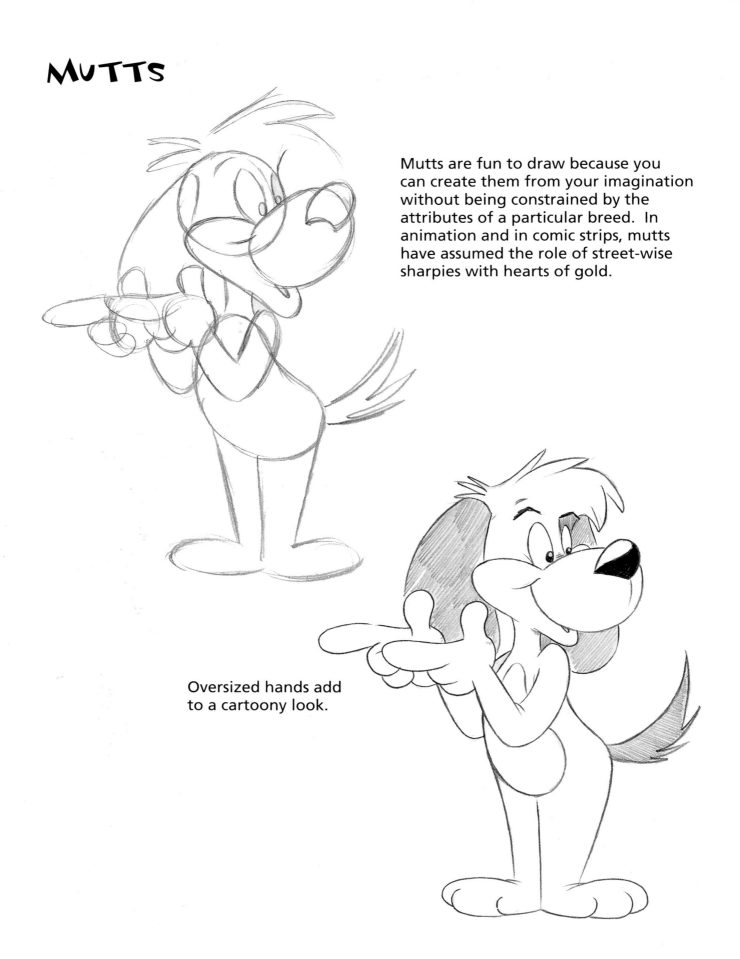

Mutts are fun to draw because you can create them from your imagination without being constrained by the attributes of a particular breed. In animation and in comic strips, mutts have assumed the role of street-wise sharpies with hearts of gold.

Oversized hands add to a cartoony look.

PUREBRED TYPES

SHEEPDOG

BEAGLE

TERRIER

DOBERMAN
PINSCHER

DACHSHUND

BLOODHOUND

DOG CONSTRUCTIONS

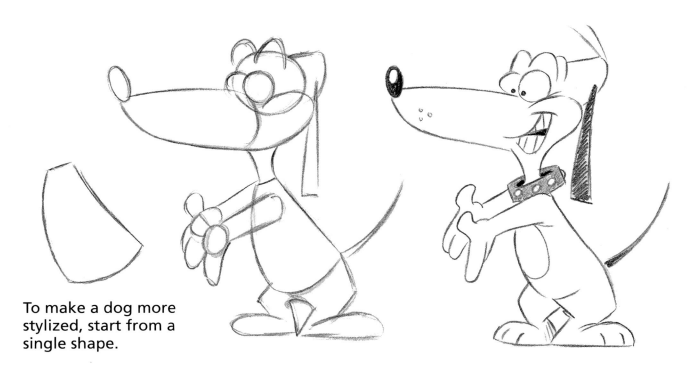

To make a dog more stylized, start from a single shape.

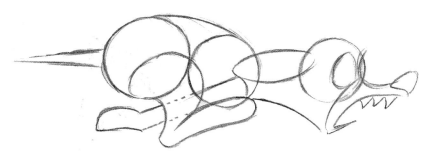

A cartoon dog in a fast run is best depicted as a four-legged creature, because it yields a more extreme pose.

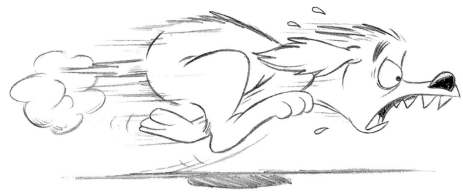

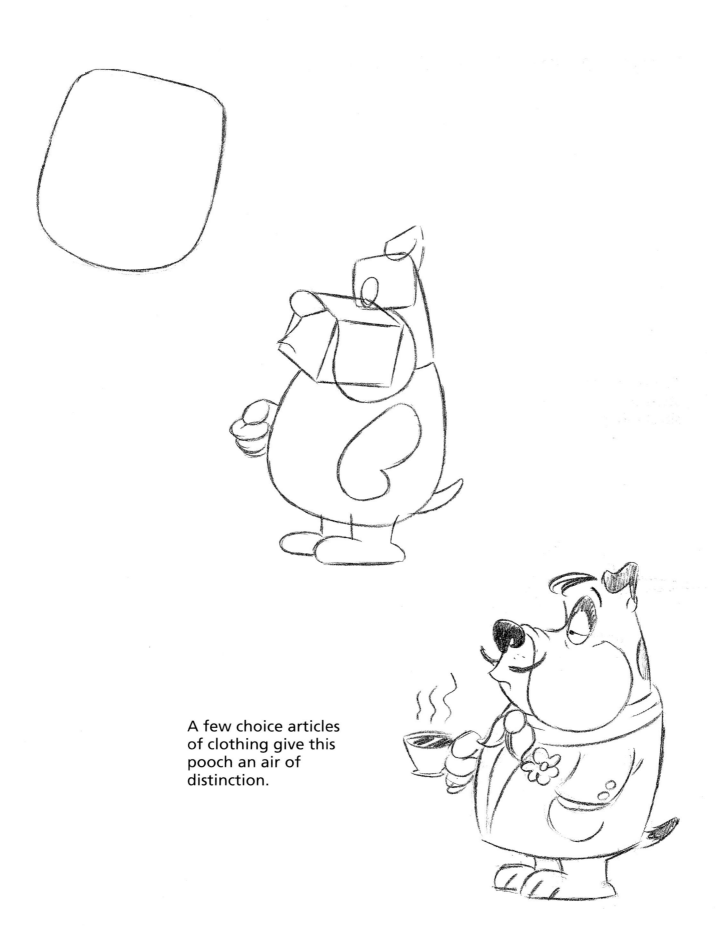

A few choice articles of clothing give this pooch an air of distinction.

CATS

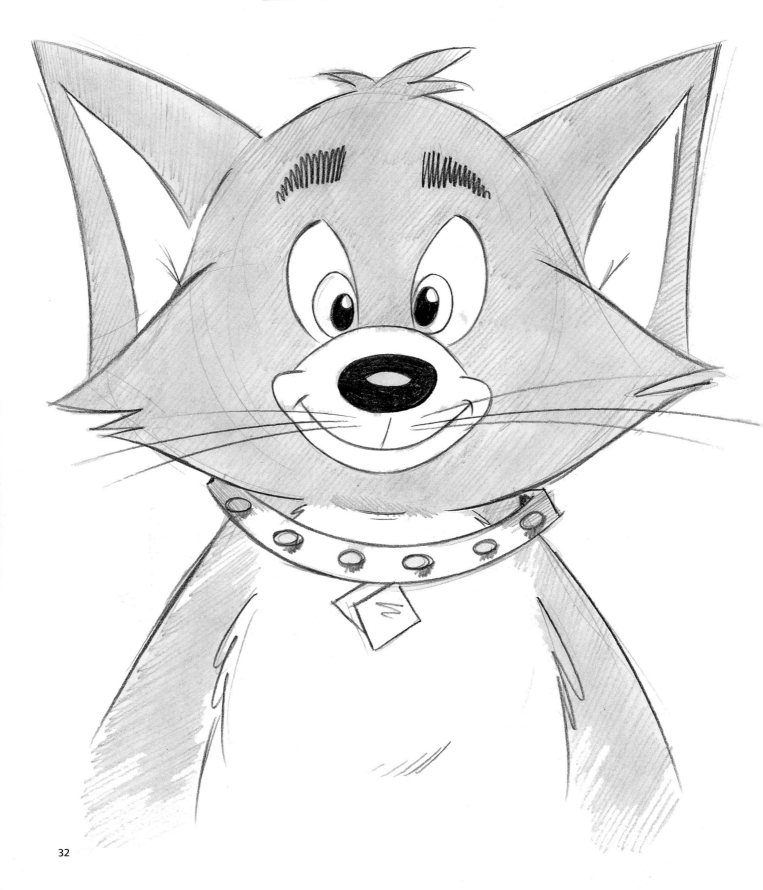

Start with this simple shape, and the rest comes easily together.

Cheeks that come to a point help to give the cat its identity.

Ear ends where the cheek begins.

Add a chubby little body.

CATS ARE AMONG THE MOST POPULAR SUBJECTS IN COMIC STRIPS & ANIMATED FILMS

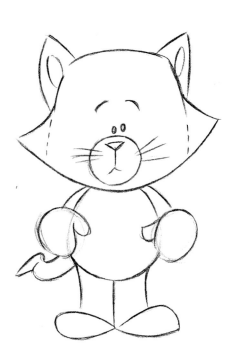

Finish with some markings.

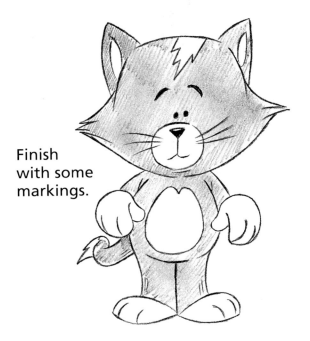

CAT MOUTHS AND NOSES

There are three basic mouth configurations
for the cartoon cat. Choose the one you like.

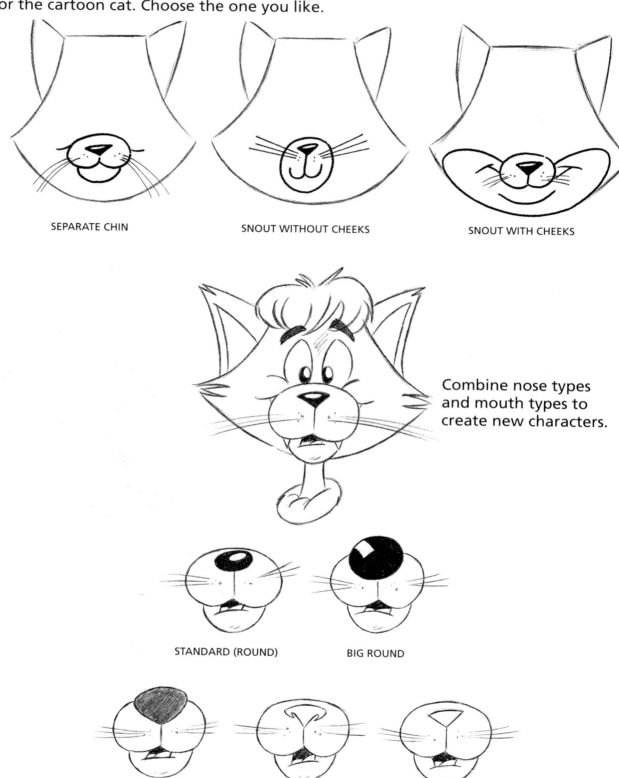

SEPARATE CHIN

SNOUT WITHOUT CHEEKS

SNOUT WITH CHEEKS

Combine nose types
and mouth types to
create new characters.

STANDARD (ROUND)

BIG ROUND

BIG TRIANGLE

TRIANGLE WITH NOSTRILS

STANDARD (TRIANGLE)

CAT CHARACTERS

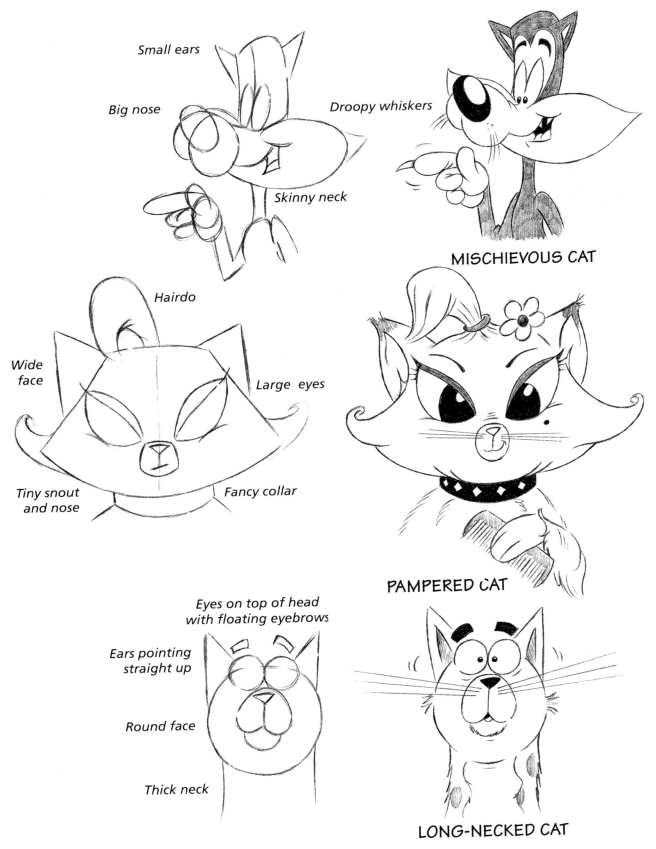

Small ears

Big nose

Droopy whiskers

Skinny neck

MISCHIEVOUS CAT

Hairdo

Wide face

Large eyes

Tiny snout and nose

Fancy collar

PAMPERED CAT

Eyes on top of head with floating eyebrows

Ears pointing straight up

Round face

Thick neck

LONG-NECKED CAT

STANDING CATS' BODIES

It is important to draw standing cats (as opposed to cats who sit on their hindquarters) with lots of energy. These cartoon types are usually in motion and up to no good.

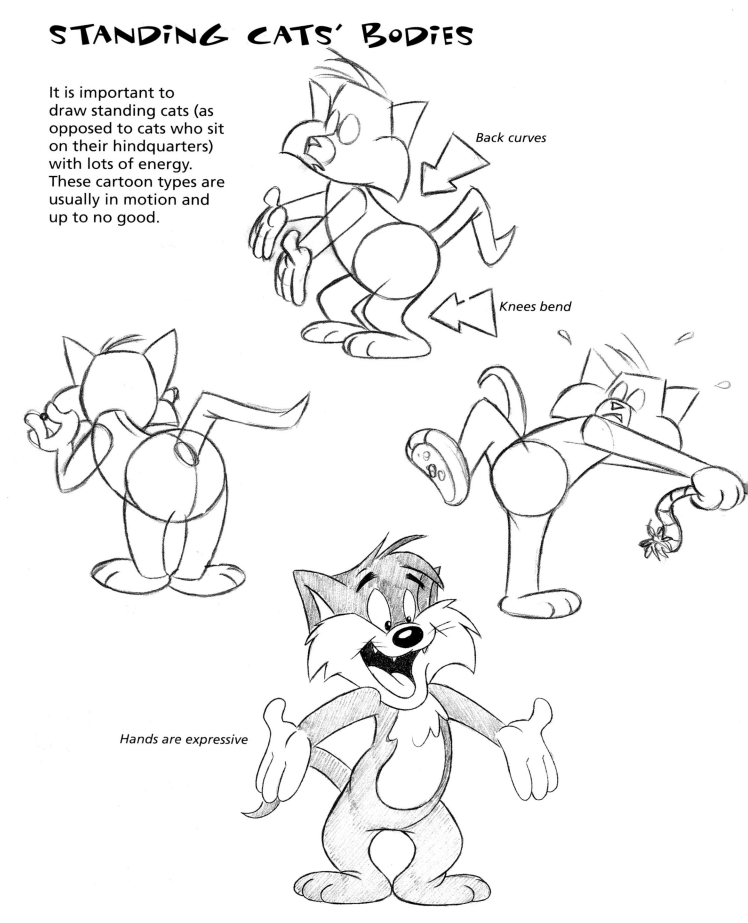

Back curves

Knees bend

Hands are expressive

SITTING CATS' BODIES

Cats who sit on their hindquarters are more droll than their standing counterparts. Sitting limits their ability to be physically as funny as the standing cat. Out of necessity, the sitting cat relies on its wits to create humor and dominate a situation. A reliance on verbal humor makes the sitting cat ideal for comic strips.

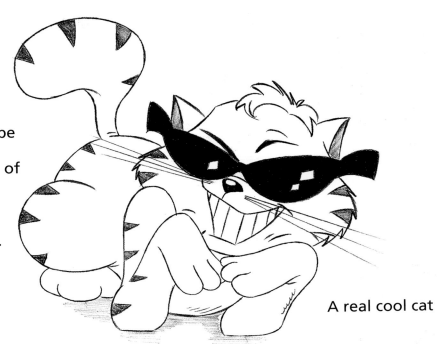

A real cool cat

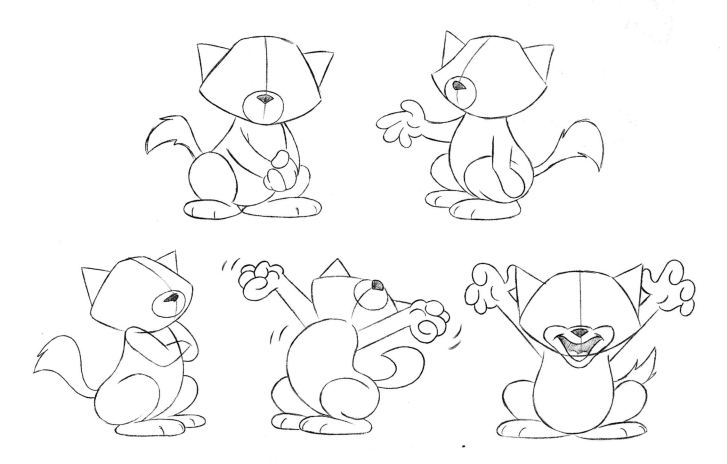

STYLIZED CATS

The larger the upper lip is, the more stylized the cat will become.

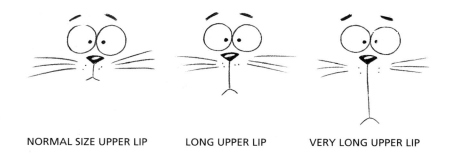

NORMAL SIZE UPPER LIP LONG UPPER LIP VERY LONG UPPER LIP

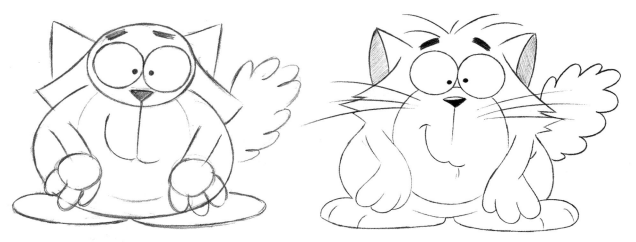

No waistline for the stylized cat—it is short and compact. Its face takes up more room than its body. The eyes are large. The arms and legs are short, almost useless.

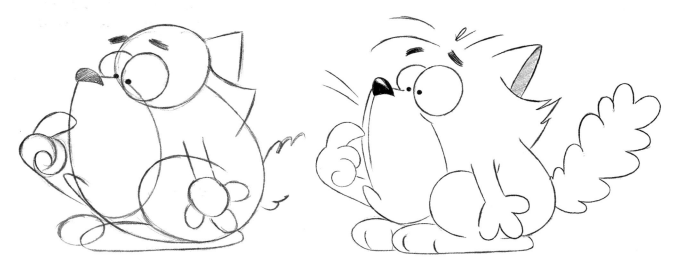

In a three-quarter view, draw the whiskers on one side of the face only (the far side), leaving the interior of the face uncluttered.

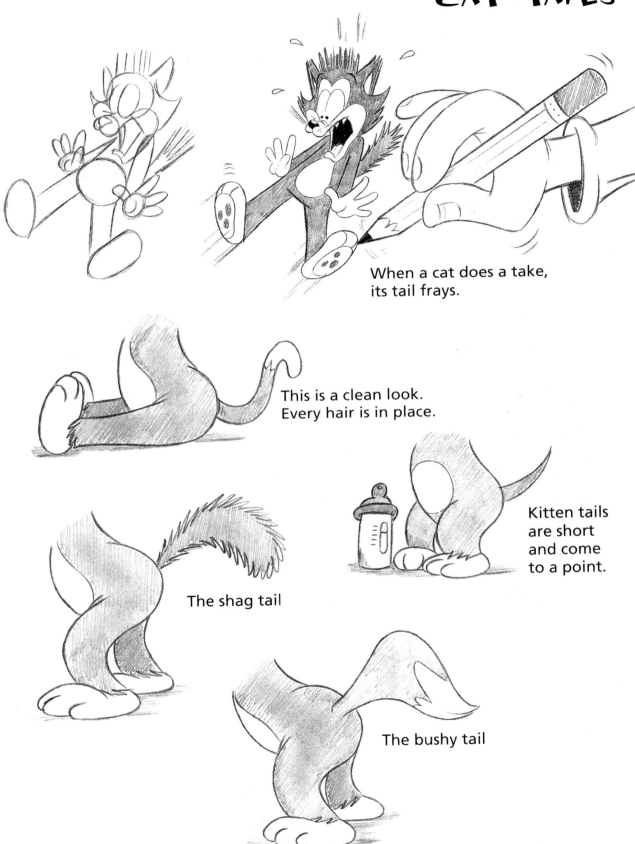

When a cat does a take,
its tail frays.

This is a clean look.
Every hair is in place.

The shag tail

Kitten tails
are short
and come
to a point.

The bushy tail

ELEPHANTS

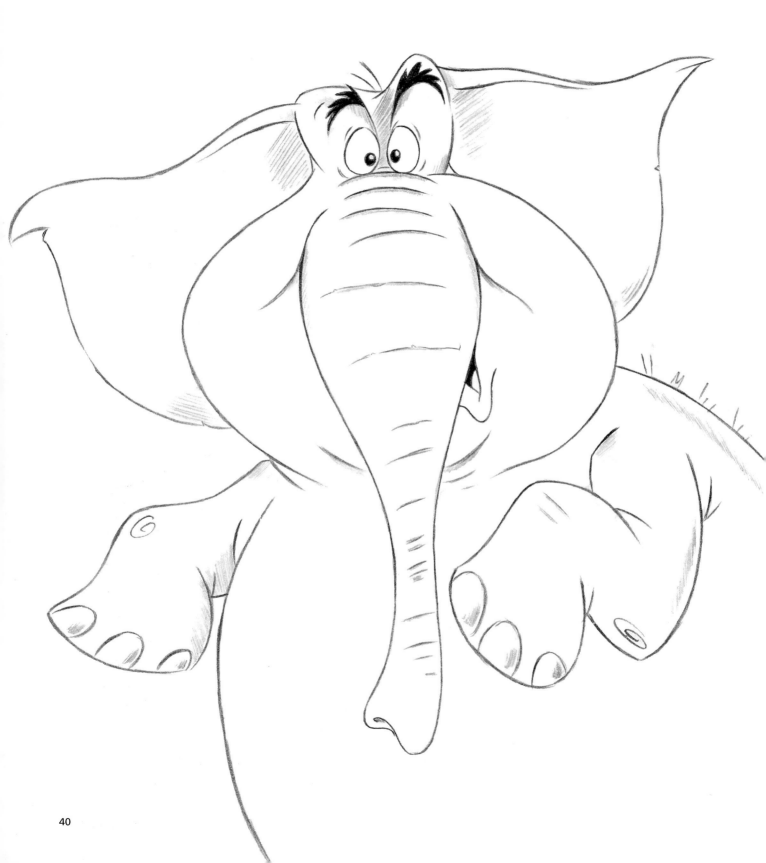

SIMPLE ELEPHANT

Here's a simple version of a circus elephant. Start with an oval.

Add a fat trunk.

Draw two small, widely placed eyes.

Add the "dent" in the top of the head, and small, floppy ears.

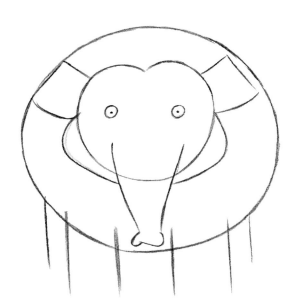

Widen the cheeks on the face. Add a second oval for the body. Indicate the legs.

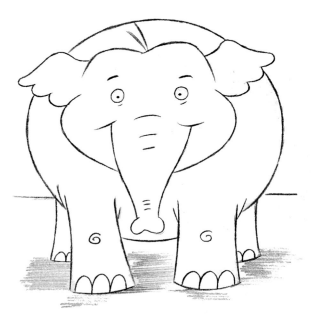

Finish and clean.

SiMPLE BoDY PROFILE

The tail is an extension of the spine.

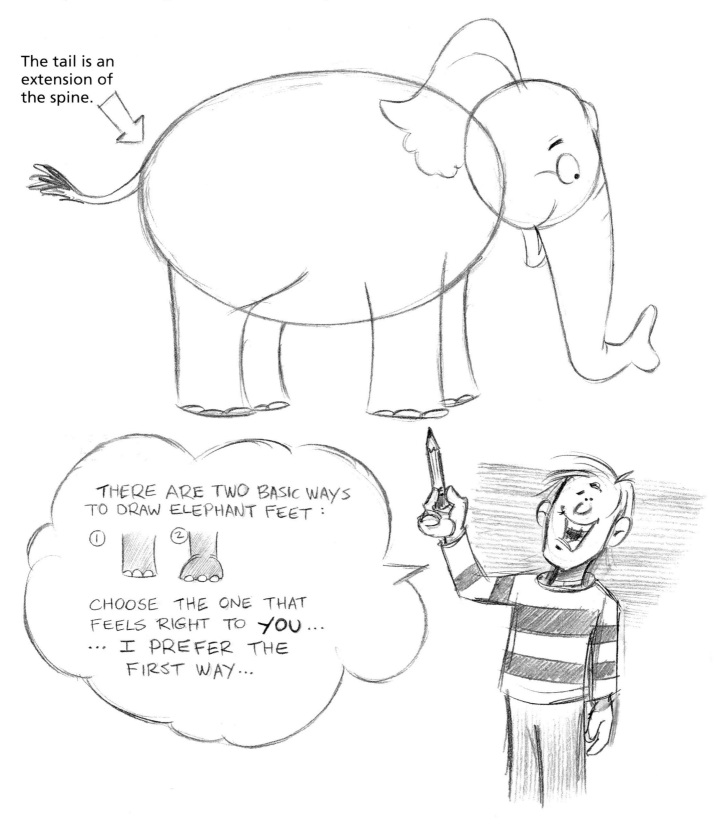

THE CLASSIC ELEPHANT

We've done simple Indian elephants, familiar in circuses. Now let's do their big-eared African cousins. You can create variations on this classic pachyderm by changing the shape of the eyes, the length of the trunk, and the size of the ears.

Divide the head into two parts:
A small skull and a huge jaw area.

The trunk is long and curving.

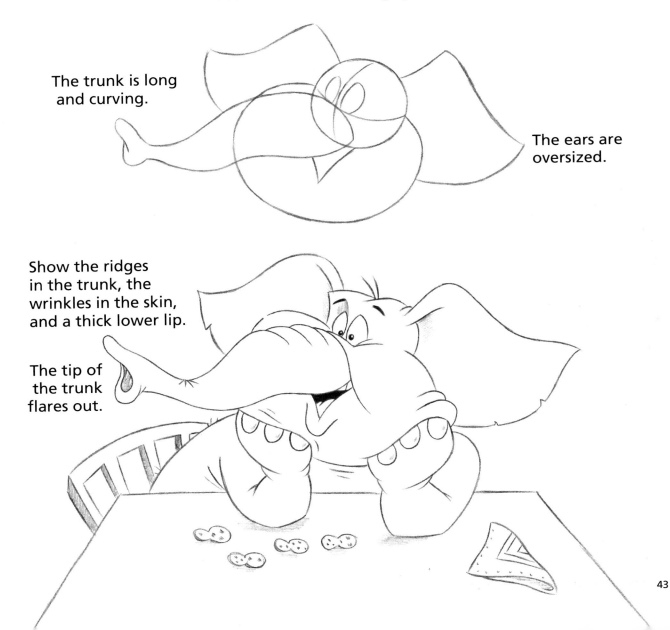

The ears are oversized.

Show the ridges in the trunk, the wrinkles in the skin, and a thick lower lip.

The tip of the trunk flares out.

ELEPHANTS WITH TUSKS

Elephant tusks come in all sizes, from short stubs to formidable weapons. Large tusks, such as these, first dip downward, then jut up sharply.

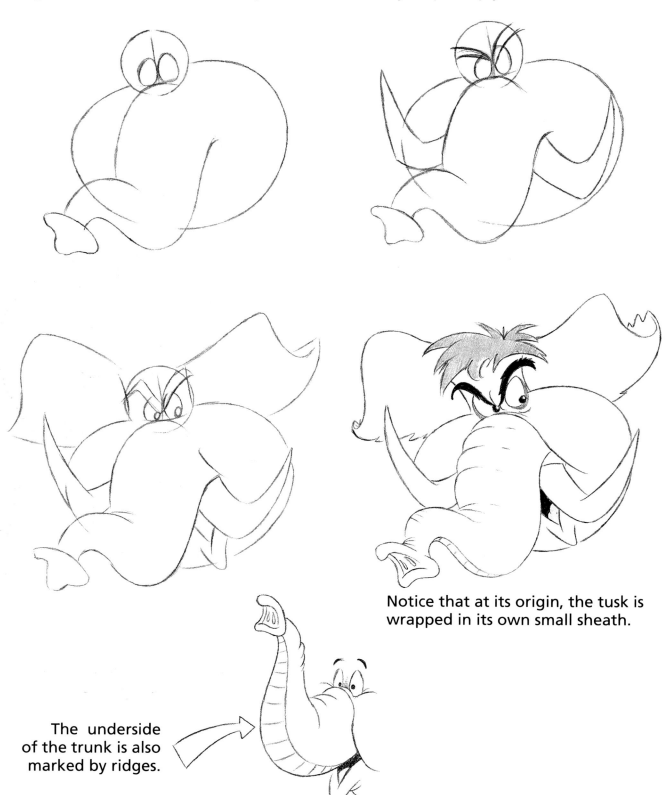

Notice that at its origin, the tusk is wrapped in its own small sheath.

The underside of the trunk is also marked by ridges.

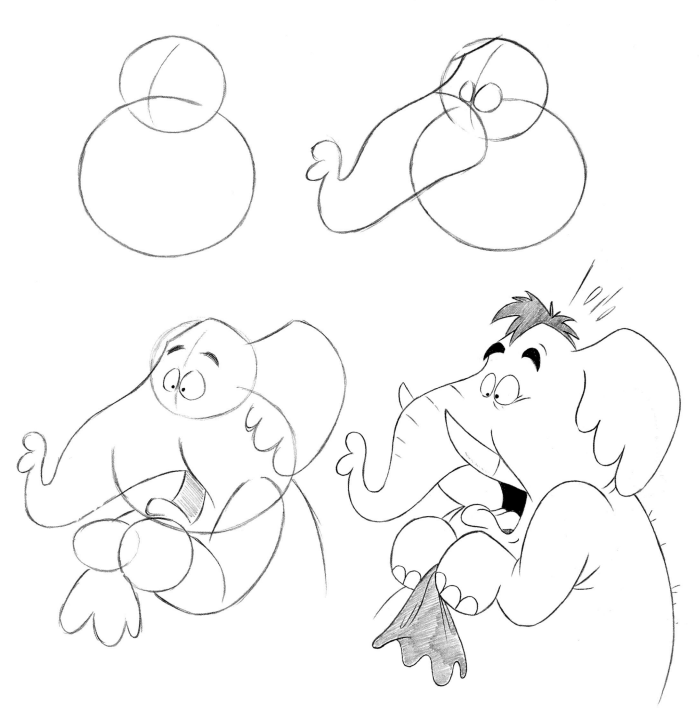

Unlike long tusks, short tusks don't dip at all. They simply jut up at a 45-degree angle.

STANDING ELEPHANT

The body in motion takes on a pear shape.

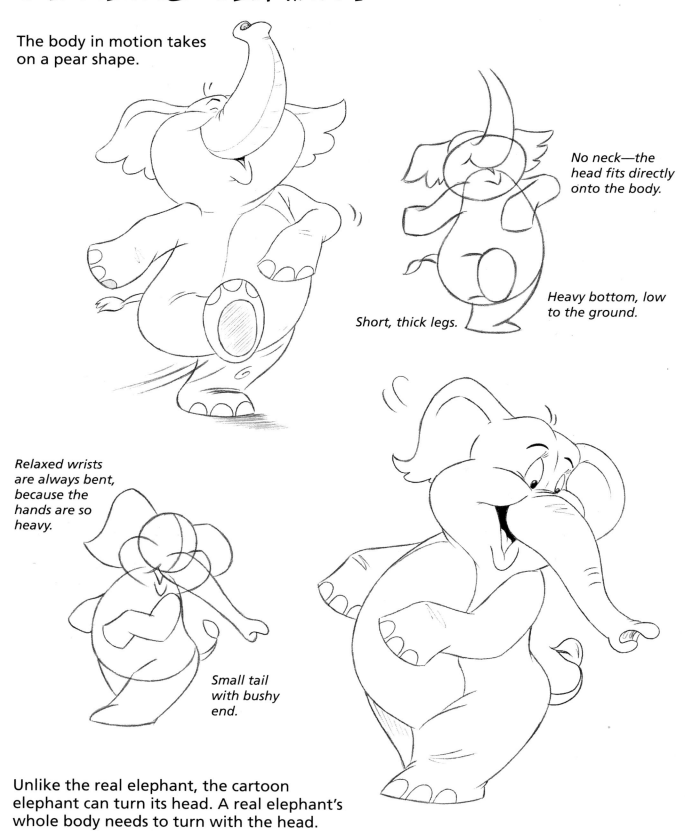

No neck—the head fits directly onto the body.

Short, thick legs.

Heavy bottom, low to the ground.

Relaxed wrists are always bent, because the hands are so heavy.

Small tail with bushy end.

Unlike the real elephant, the cartoon elephant can turn its head. A real elephant's whole body needs to turn with the head.

STYLIZED VS. CLASSIC ELEPHANT

Sometimes it's fun to break the rules. To stylize a cartoon animal, take it as far as possible from its traditional appearance. The trick is to leave the essential form, which makes it recognizable. Even a stylized elephant must be fat and have a trunk if it is to be recognized as an elephant.

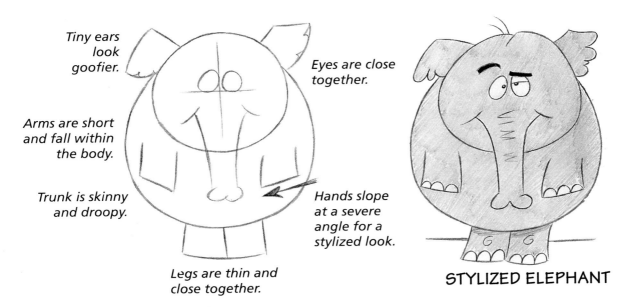

Tiny ears look goofier.

Eyes are close together.

Arms are short and fall within the body.

Trunk is skinny and droopy.

Hands slope at a severe angle for a stylized look.

Legs are thin and close together.

STYLIZED ELEPHANT

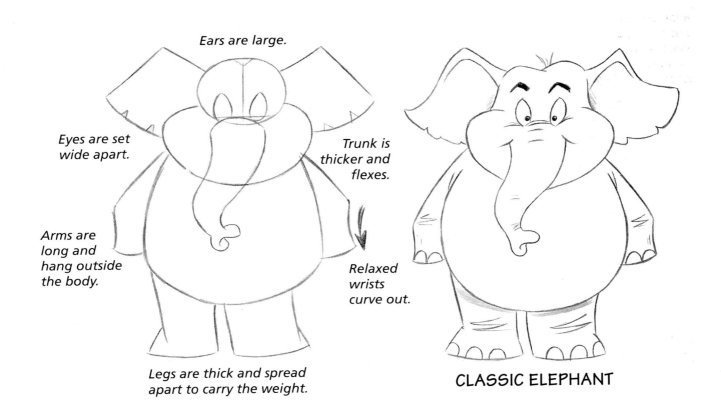

Ears are large.

Eyes are set wide apart.

Trunk is thicker and flexes.

Arms are long and hang outside the body.

Relaxed wrists curve out.

Legs are thick and spread apart to carry the weight.

CLASSIC ELEPHANT

BEARS

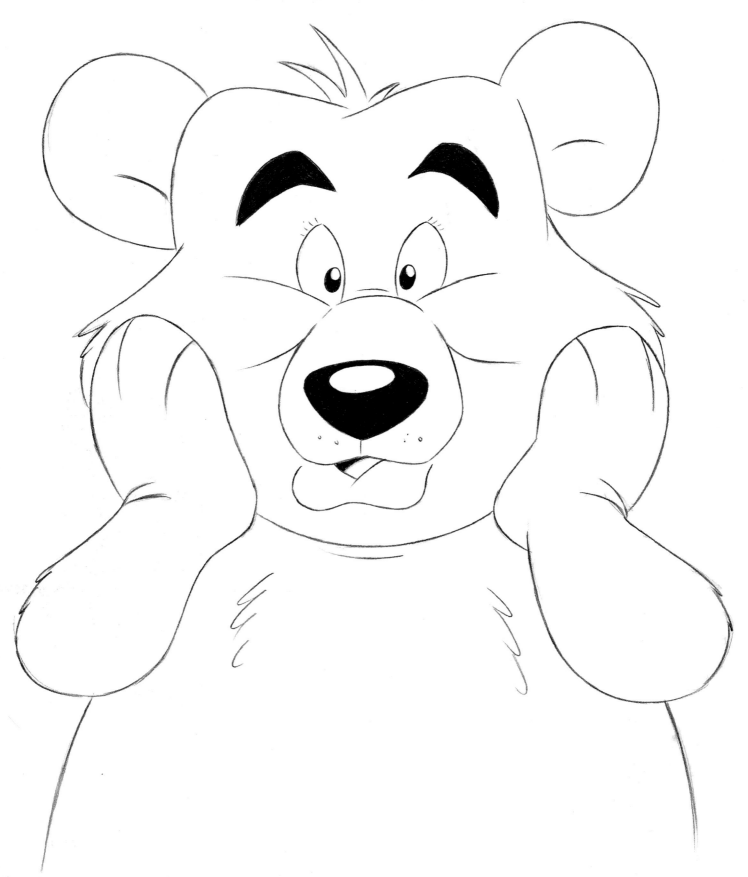

SIMPLE BEAR

With a little practice, you'll master this in no time.

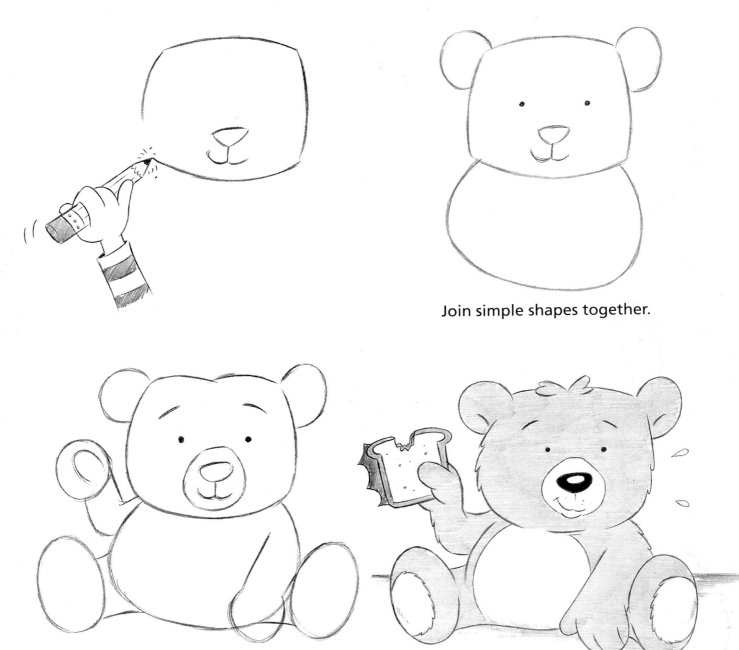

Join simple shapes together.

For the finish, add ruffled fur.

BEAR TYPES

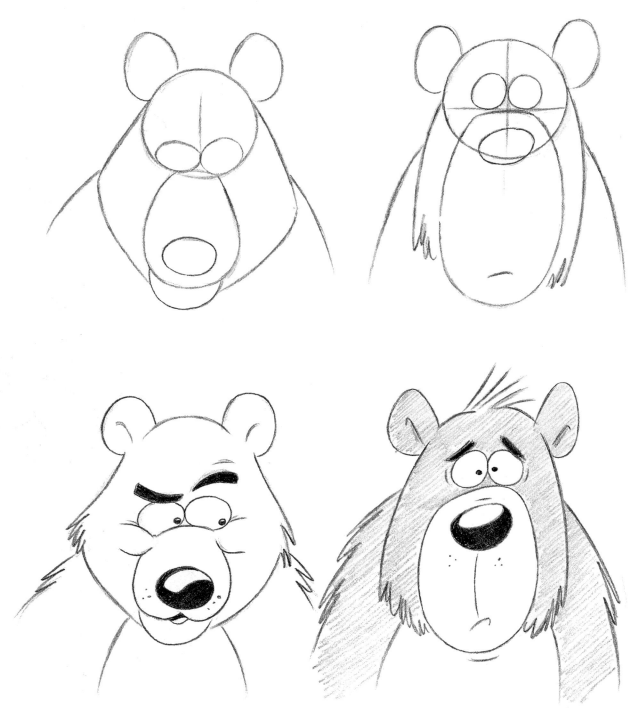

POLAR BEAR
Characterized by a white face
with a smooth top.

BROWN BEAR
The standard cartoon bear.

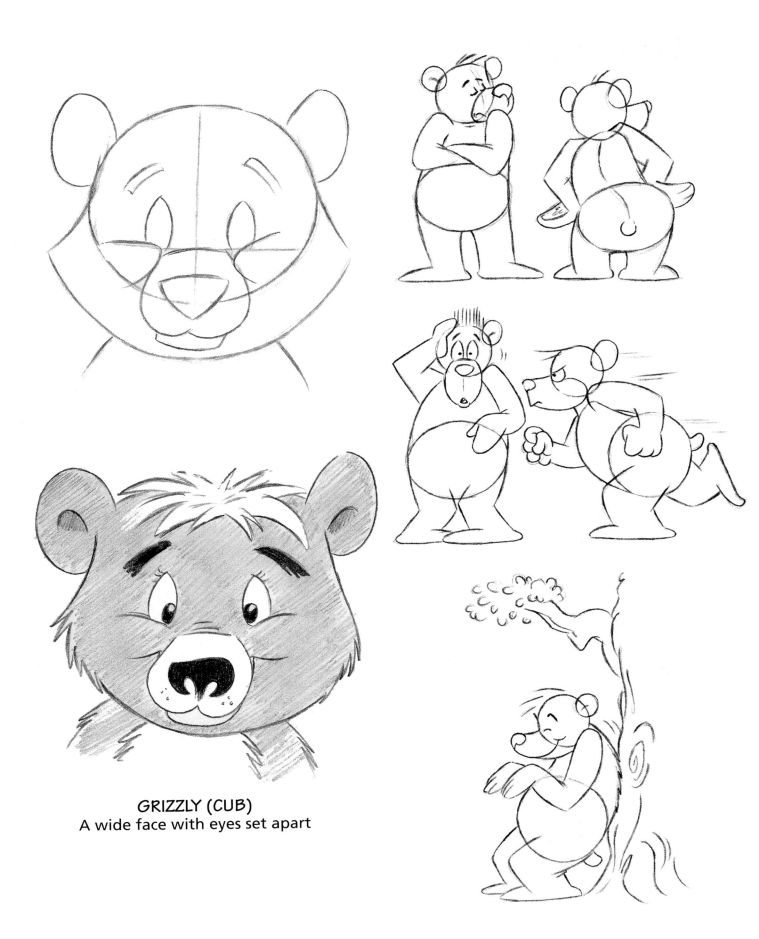

GRIZZLY (CUB)
A wide face with eyes set apart

Bear Anatomy

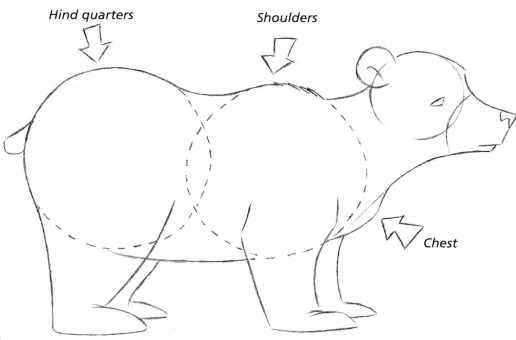

Hind quarters

Shoulders

Chest

REAL BEARS
The real-life bear's body is based on overlapping circles. It has three major areas that protrude.

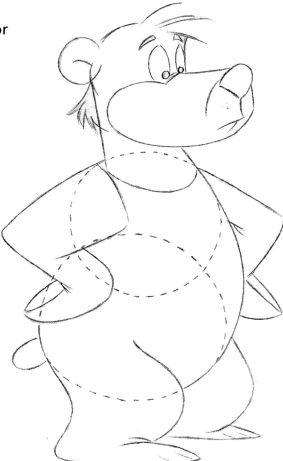

CARTOON BEARS
The cartoon bear is also based on overlapping circles, but these are stacked up and down. Also, the real bear's cartoon cousin has no protruding chest.

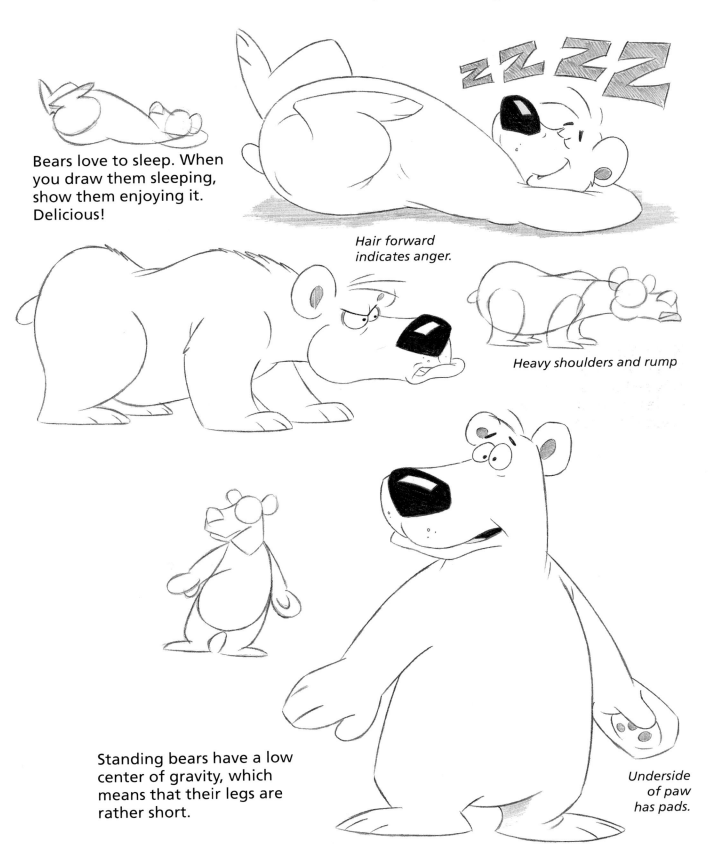

Bears love to sleep. When you draw them sleeping, show them enjoying it. Delicious!

Hair forward indicates anger.

Heavy shoulders and rump

Standing bears have a low center of gravity, which means that their legs are rather short.

Underside of paw has pads.

GROWLING BEARS

A growl is a wonderfully expressive sound used to signal anger or bad intentions.

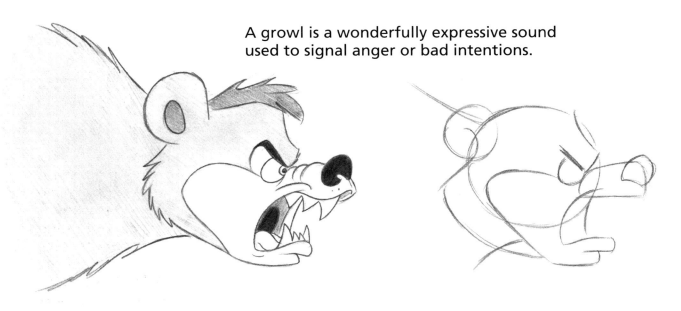

Fur ruffles on head, neck, and shoulders.

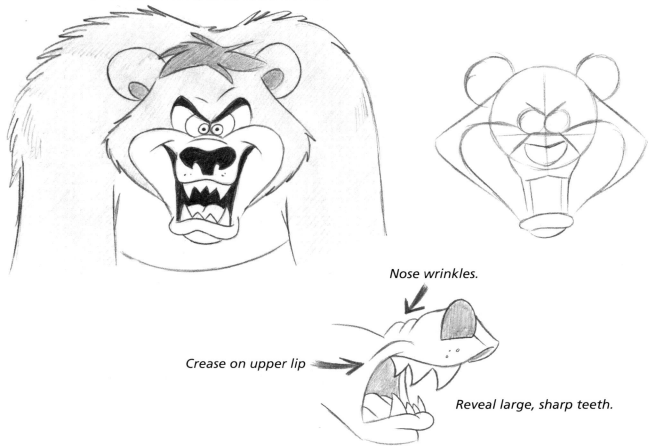

Nose wrinkles.

Crease on upper lip

Reveal large, sharp teeth.

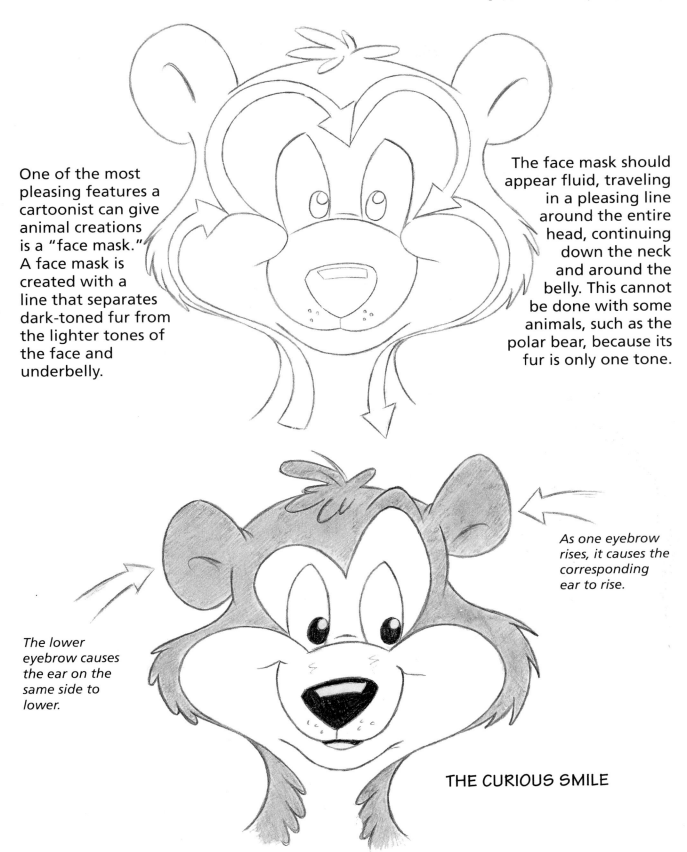

One of the most pleasing features a cartoonist can give animal creations is a "face mask." A face mask is created with a line that separates dark-toned fur from the lighter tones of the face and underbelly.

The face mask should appear fluid, traveling in a pleasing line around the entire head, continuing down the neck and around the belly. This cannot be done with some animals, such as the polar bear, because its fur is only one tone.

As one eyebrow rises, it causes the corresponding ear to rise.

The lower eyebrow causes the ear on the same side to lower.

THE CURIOUS SMILE

ENERGY IN A POSE

Notice how every part of the body, as well as each limb, is in motion. Even the head is cocked toward the right shoulder.

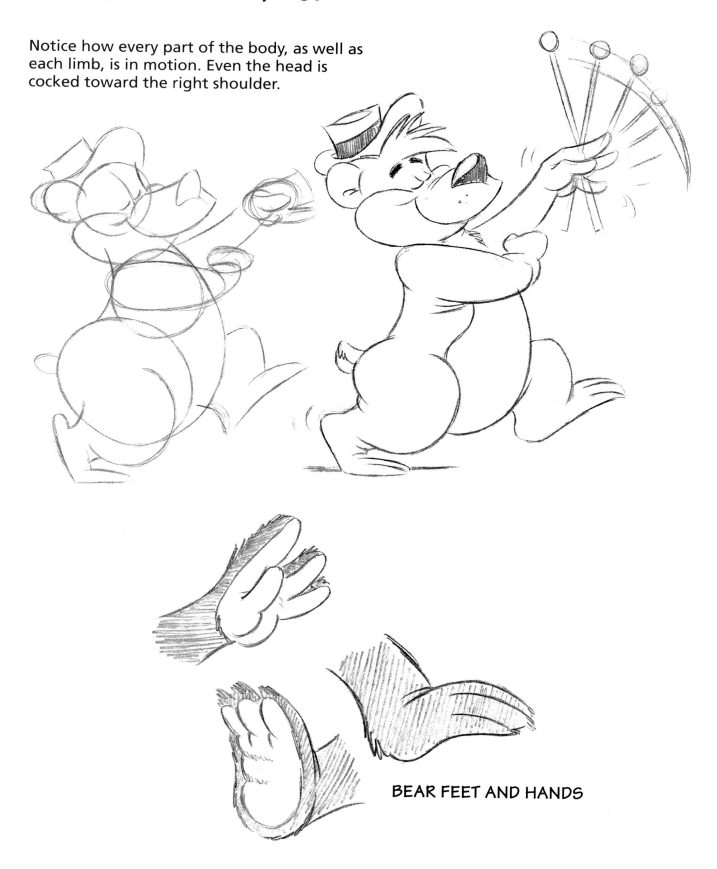

BEAR FEET AND HANDS

BULLY BEAR

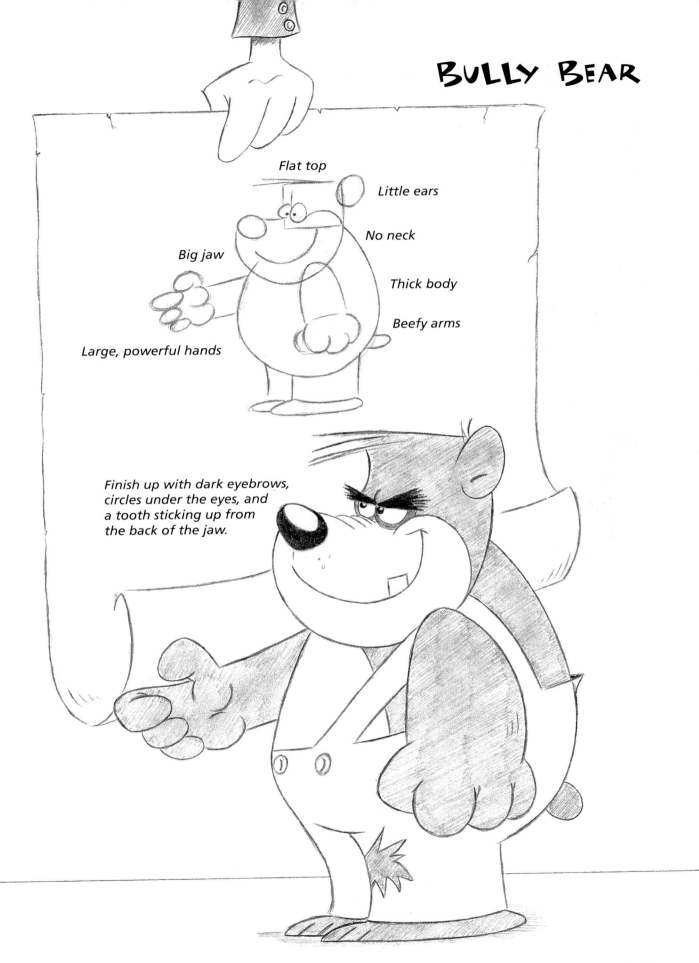

Flat top

Little ears

No neck

Thick body

Big jaw

Beefy arms

Large, powerful hands

Finish up with dark eyebrows, circles under the eyes, and a tooth sticking up from the back of the jaw.

APES

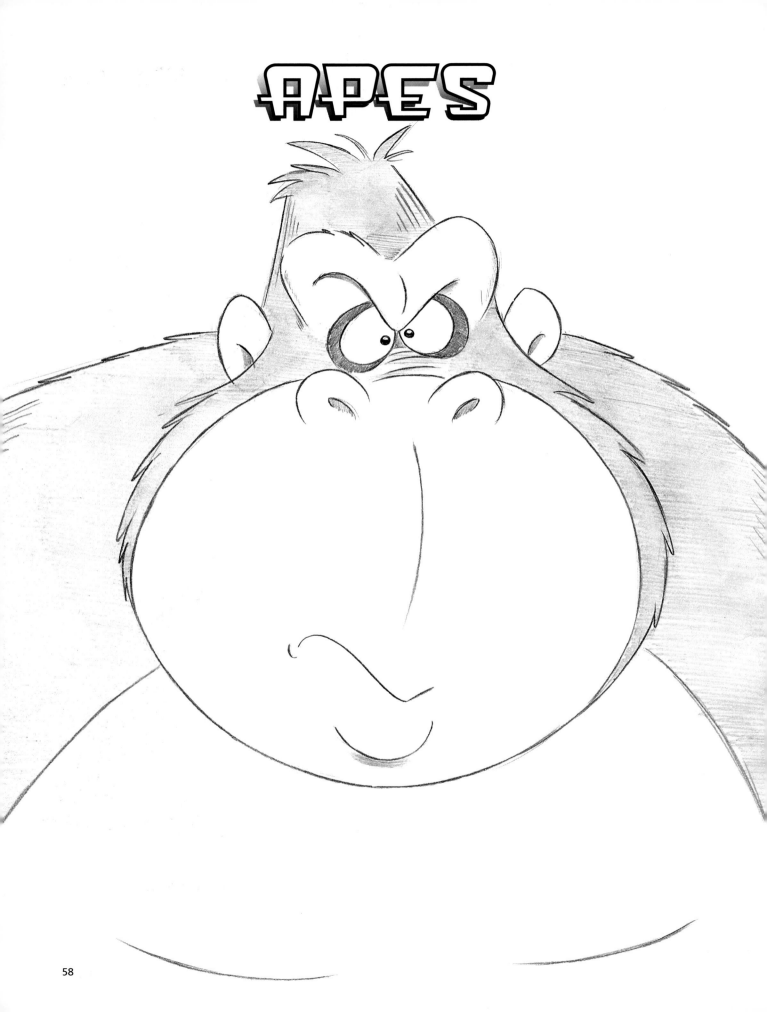

Gorillas are popularly featured in animated film and television cartoons. They are broad, hilarious characters of immense physical strength.

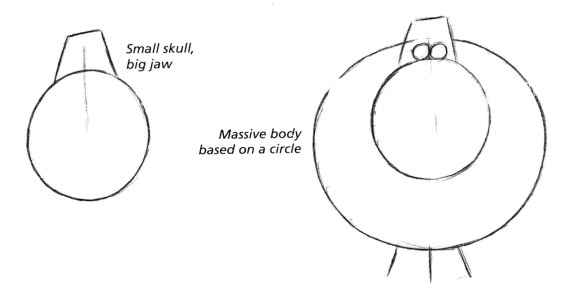

Small skull, big jaw

Massive body based on a circle

Gorillas have long arms and big shoulders. Their legs are short, and their feet are flat. Their huge hands are powerful.

High forehead

Muscular eyebrows

Little ears

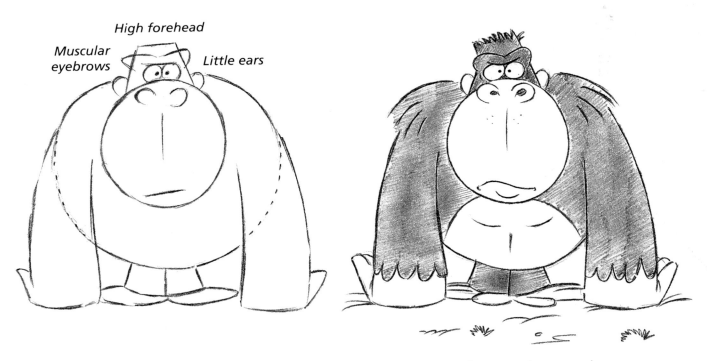

Knuckles press the ground.

GORILLA POSTURE

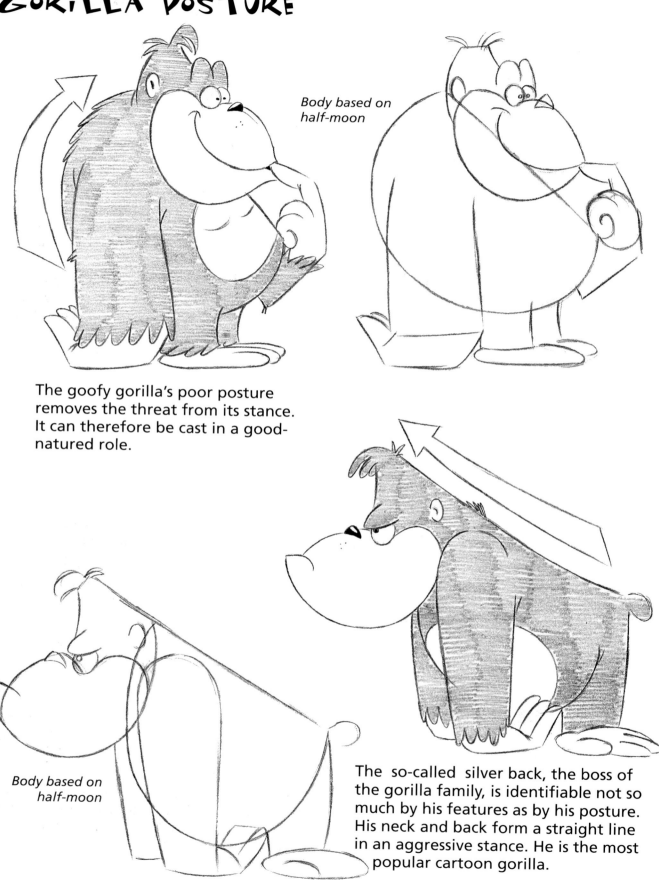

Body based on half-moon

The goofy gorilla's poor posture removes the threat from its stance. It can therefore be cast in a good-natured role.

Body based on half-moon

The so-called silver back, the boss of the gorilla family, is identifiable not so much by his features as by his posture. His neck and back form a straight line in an aggressive stance. He is the most popular cartoon gorilla.

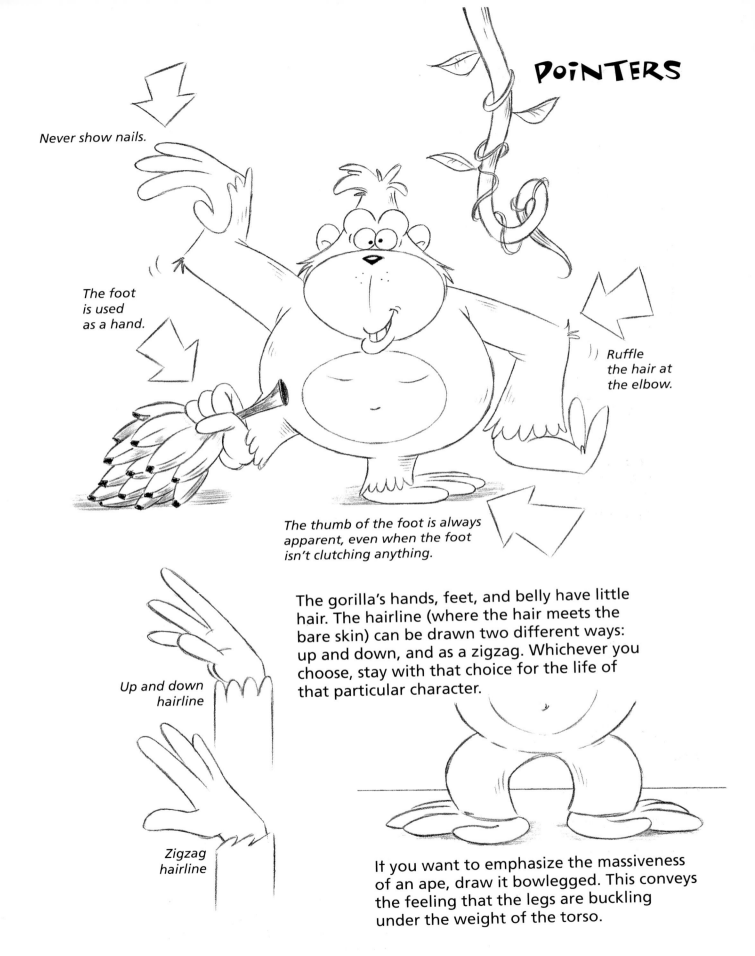

Never show nails.

The foot
is used
as a hand.

Ruffle
the hair at
the elbow.

The thumb of the foot is always
apparent, even when the foot
isn't clutching anything.

The gorilla's hands, feet, and belly have little
hair. The hairline (where the hair meets the
bare skin) can be drawn two different ways:
up and down, and as a zigzag. Whichever you
choose, stay with that choice for the life of
that particular character.

Up and down
hairline

Zigzag
hairline

It you want to emphasize the massiveness
of an ape, draw it bowlegged. This conveys
the feeling that the legs are buckling
under the weight of the torso.

BAD GUY APES

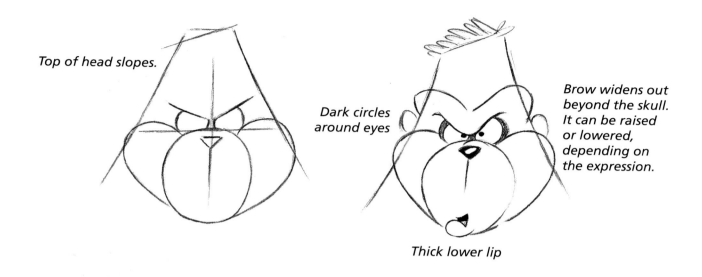

Top of head slopes.

Dark circles around eyes

Brow widens out beyond the skull. It can be raised or lowered, depending on the expression.

Thick lower lip

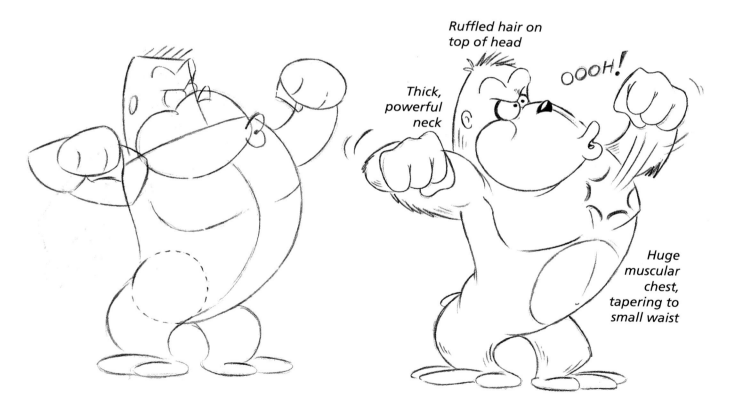

Start with an aggressive stance.

Ruffled hair on top of head

Thick, powerful neck

OOOH!

Huge muscular chest, tapering to small waist

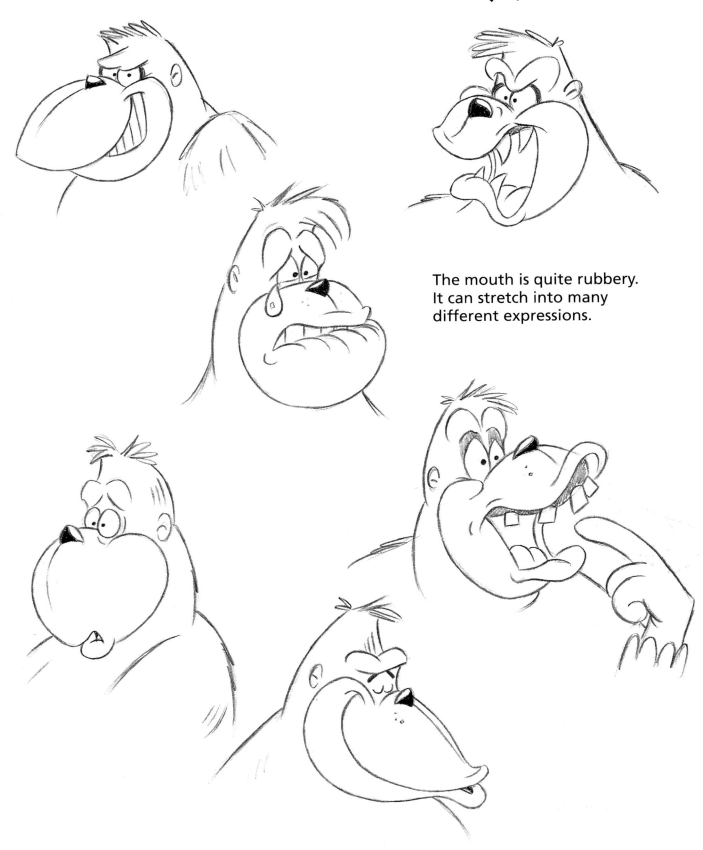

The mouth is quite rubbery. It can stretch into many different expressions.

APE LOCOMOTION

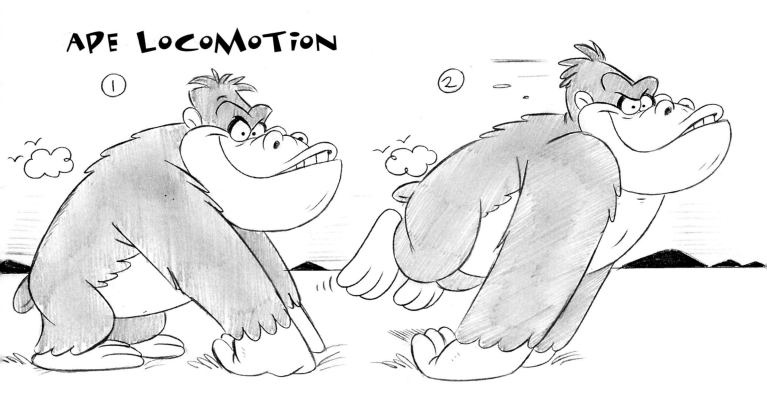

① ②

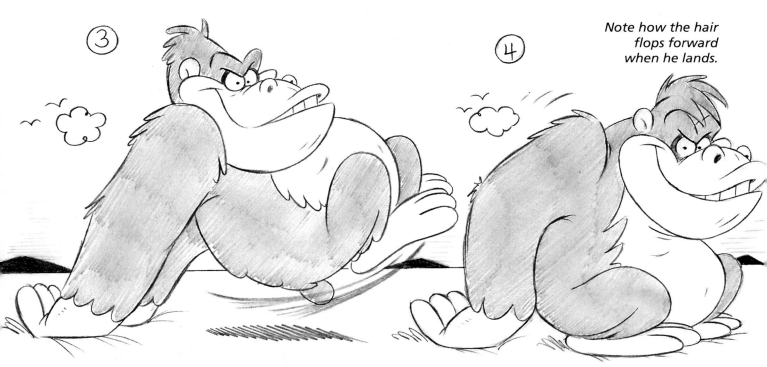

③ ④

Note how the hair flops forward when he lands.

The term "cycle," when used in animation, is a series of drawings that repeat to give the illusion of continuous motion. The gorilla starts at drawing #1; shoves himself forward at #2; swings his torso over the ground in #3; and lands in #4, ready to propel himself again in #1. These drawings are called "extremes," or key poses. Several more drawings called "in-betweens" are needed in the series— they fall between the key poses—to smooth out the action.

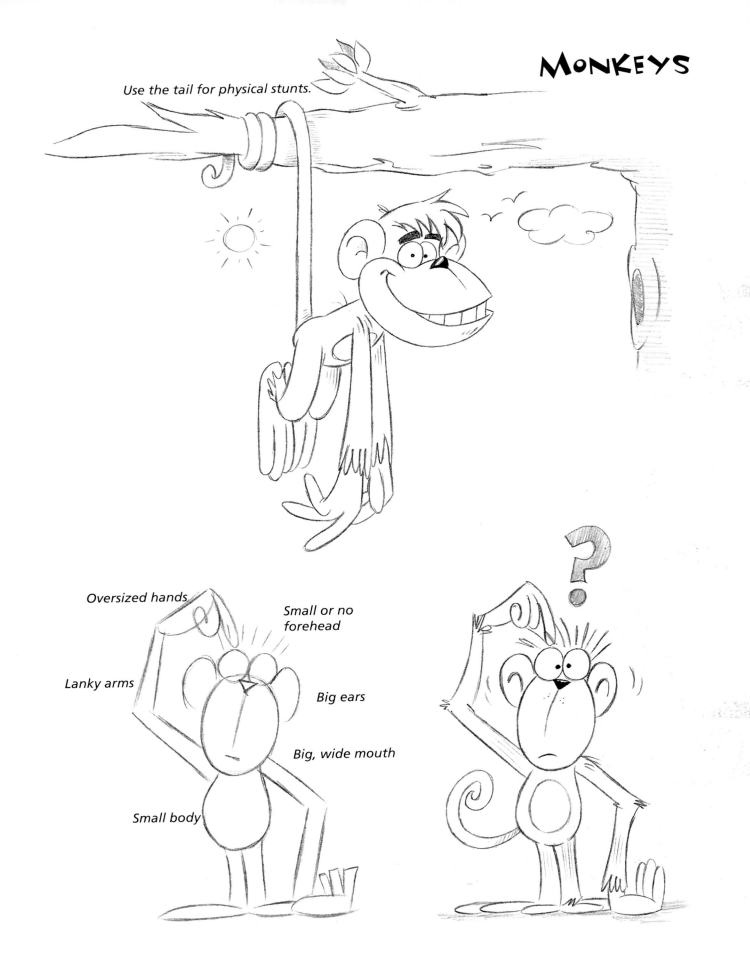

Use the tail for physical stunts.

Oversized hands

Small or no forehead

Lanky arms

Big ears

Big, wide mouth

Small body

LIONS

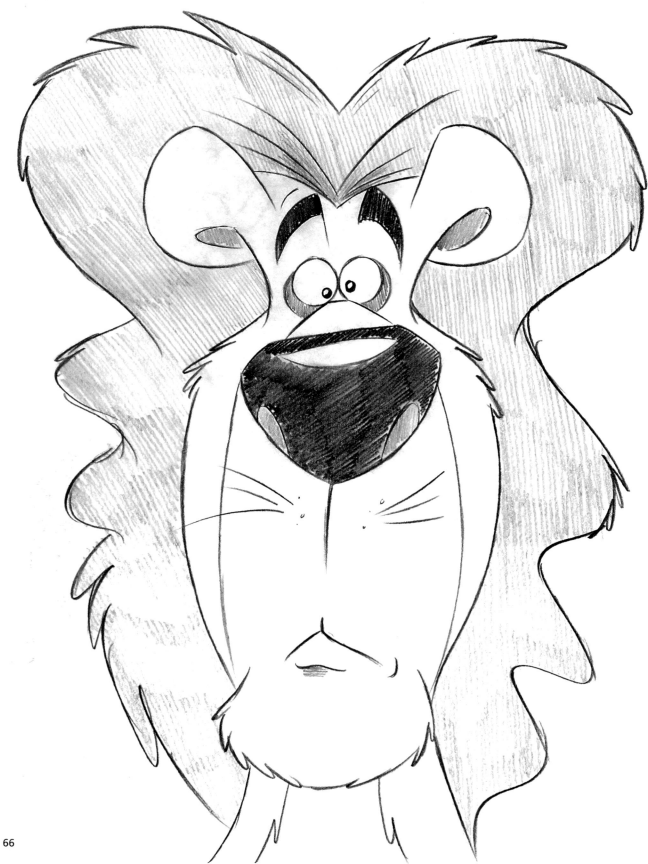

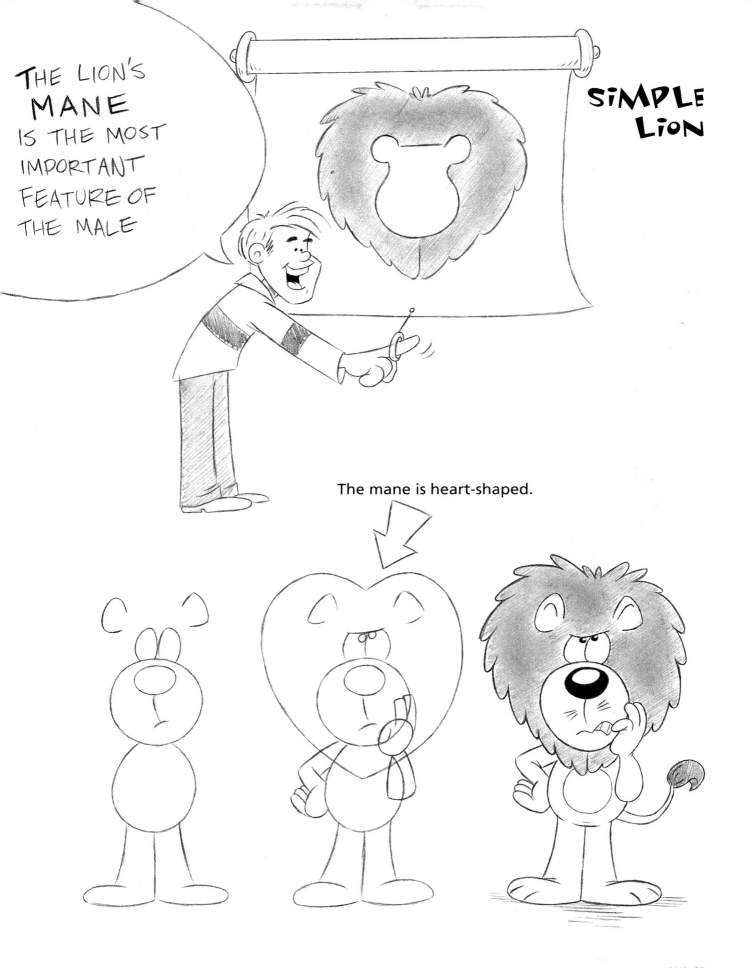

The mane is heart-shaped.

LION'S SNOUT

On a lion, the snout ends in a ball shape.

As a guide, draw a line down the center of the snout. The bottom of the nose affixes to this center line. The center line begins here.

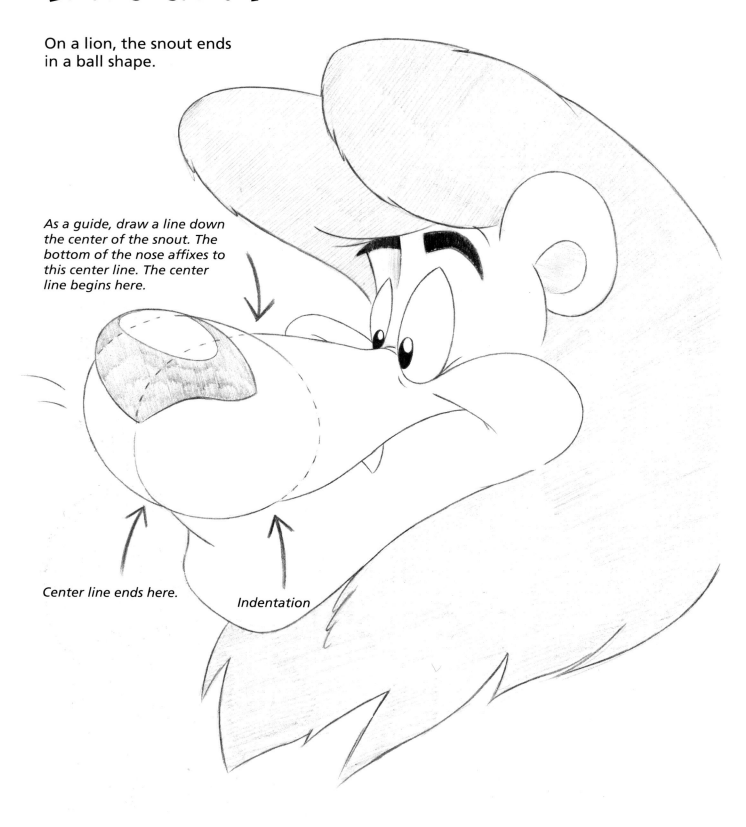

Center line ends here.

Indentation

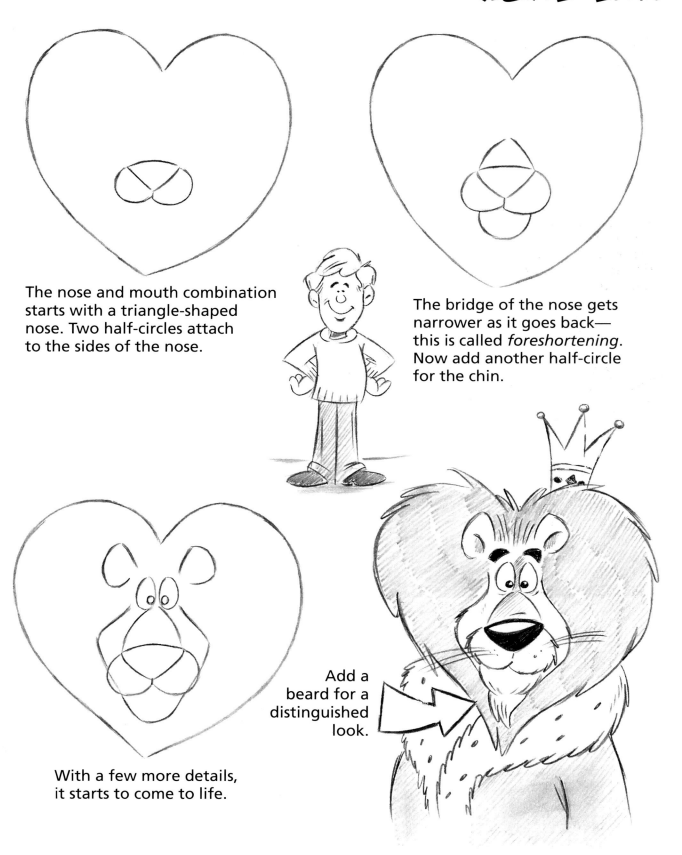

The nose and mouth combination starts with a triangle-shaped nose. Two half-circles attach to the sides of the nose.

The bridge of the nose gets narrower as it goes back— this is called *foreshortening*. Now add another half-circle for the chin.

With a few more details, it starts to come to life.

Add a beard for a distinguished look.

Goofy Lion

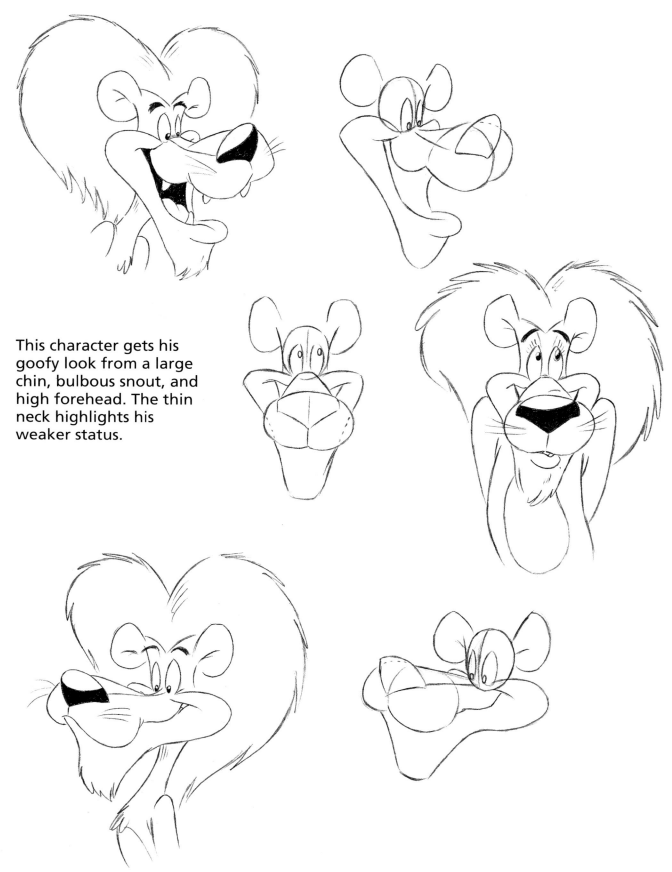

This character gets his goofy look from a large chin, bulbous snout, and high forehead. The thin neck highlights his weaker status.

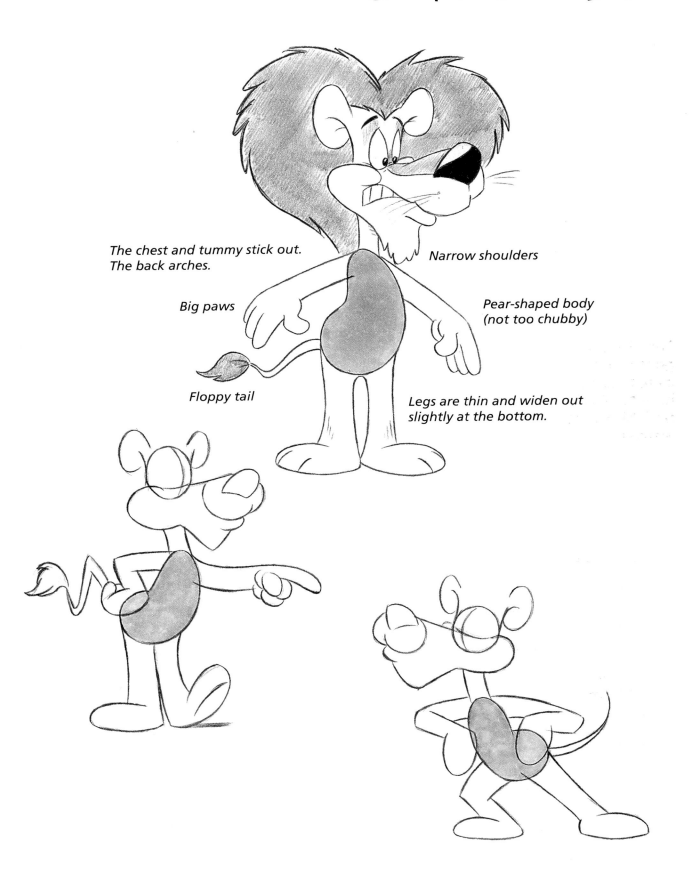

The chest and tummy stick out.
The back arches.

Narrow shoulders

Big paws

Pear-shaped body
(not too chubby)

Floppy tail

Legs are thin and widen out
slightly at the bottom.

REALITY-BASED LION

To draw a more realistic cartoon lion, such as you might find in children's-book illustration, space the eyes farther apart. Eliminate the round cheeks. Allow the bulk of the mane to gather below the ears.

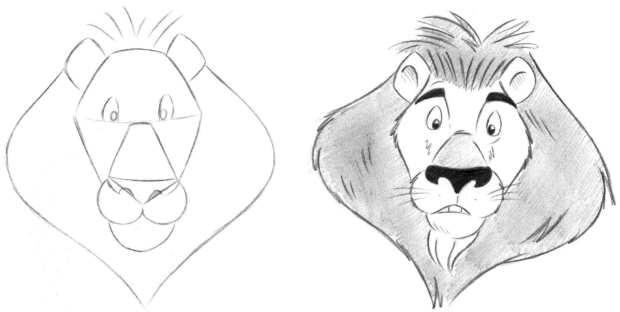

LION VILLAIN

The villain is characterized by his long, sharp claws and his menacing eyebrows. Emphasize the cat quality of the eyes for the villain. Note, too, his powerful body.

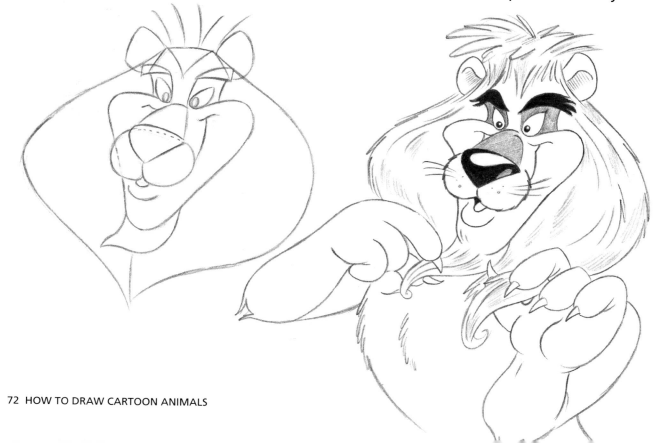

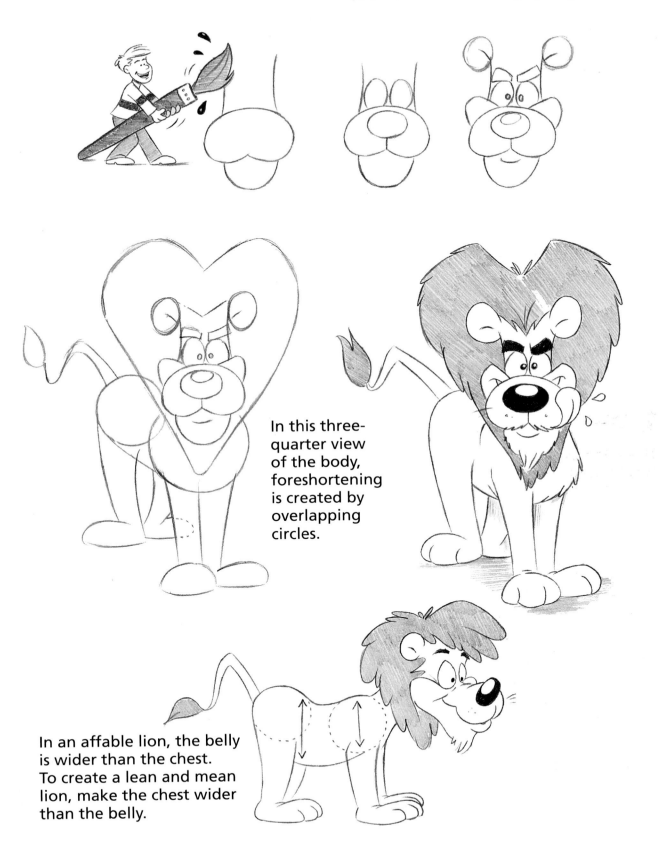

In this three-quarter view of the body, foreshortening is created by overlapping circles.

In an affable lion, the belly is wider than the chest. To create a lean and mean lion, make the chest wider than the belly.

COIL, LEAP, AND POUNCE

In animated cartoon work, key poses are essential to charting the movement.

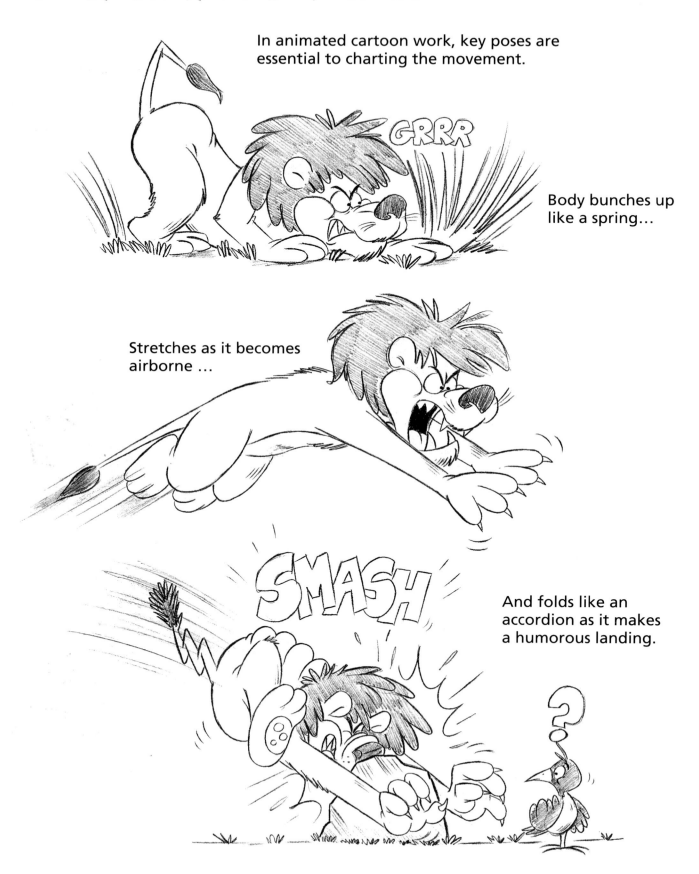

GRRR

Body bunches up like a spring…

Stretches as it becomes airborne …

SMASH

And folds like an accordion as it makes a humorous landing.

LiONESS

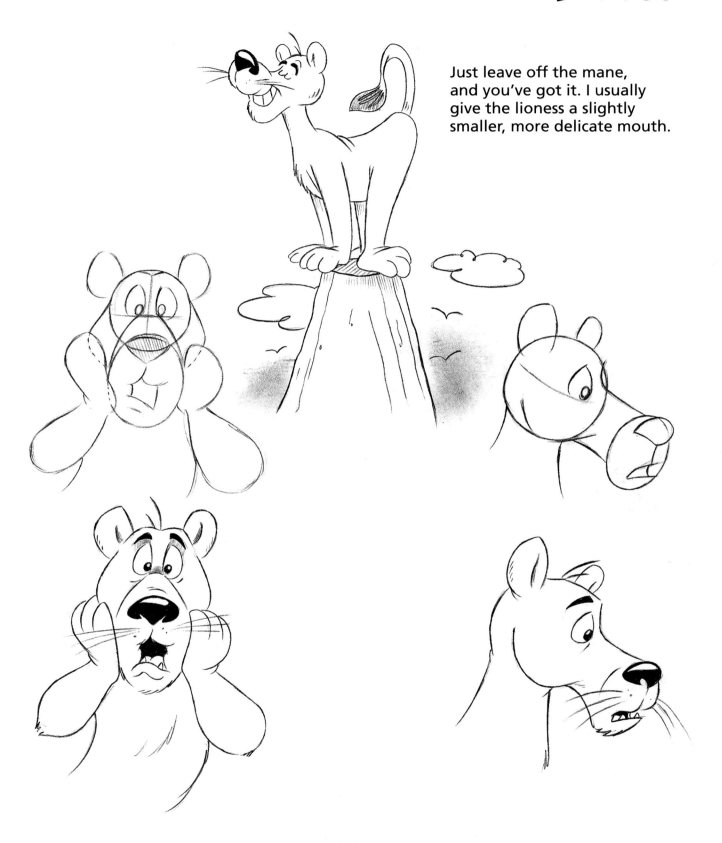

Just leave off the mane, and you've got it. I usually give the lioness a slightly smaller, more delicate mouth.

TIGERS

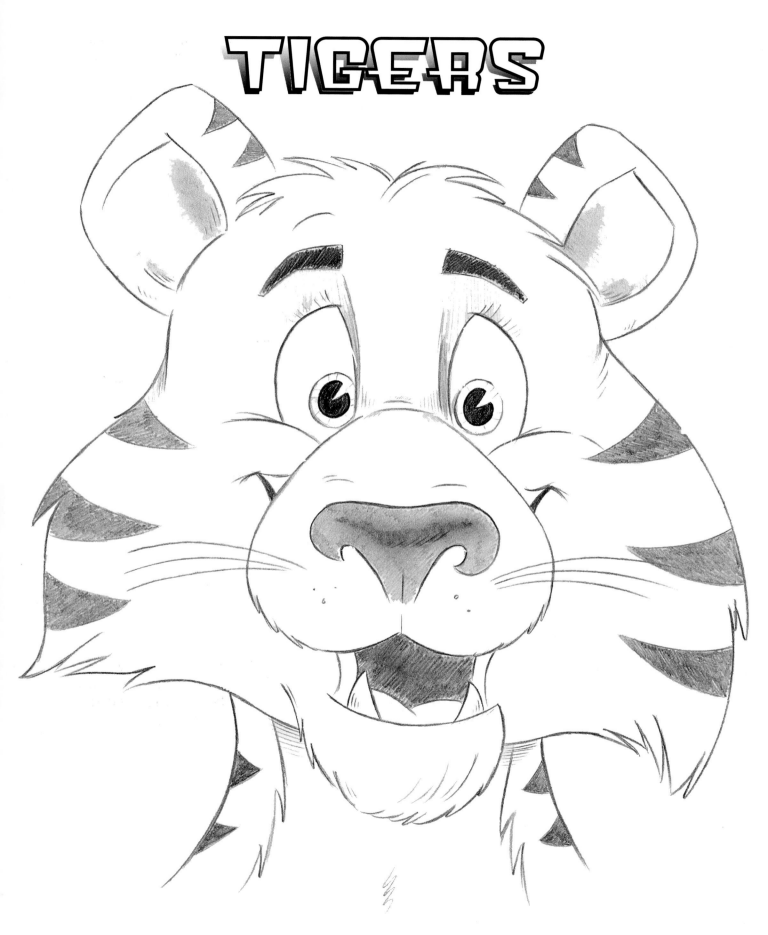

COMPARING CATS

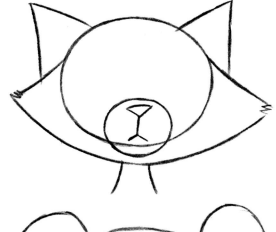

DOMESTIC
Small nose, snout, and mouth. Cheeks narrow to a point. Ears are triangular. Neck is thin.

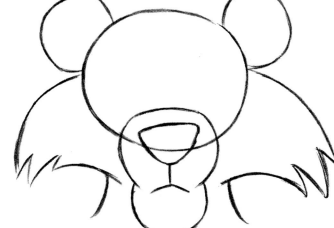

TIGER
Bear-like ears. Large chin. Face fur slopes downward. Thick neck.

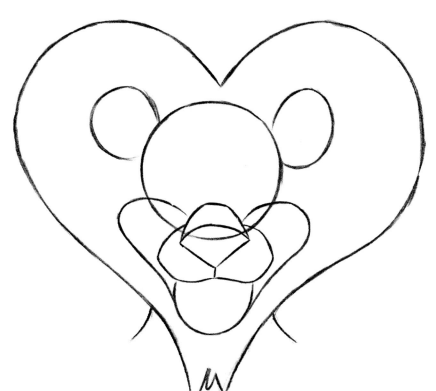

LION
Pronounced mane. Cheeks are smooth, not ruffled. Snout is more pronounced.

TIGER ANATOMY

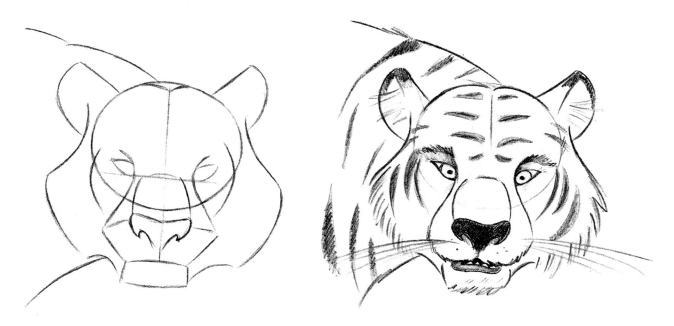

REAL-LIFE TIGER
The real tiger is an awesome and frightening creature.

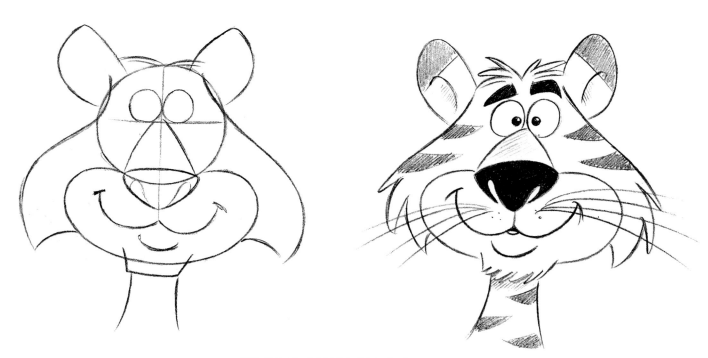

SIMPLE CARTOON TIGER
To create the cartoon version, eliminate most of the forehead,
bring the eyes close together and widen the mouth.

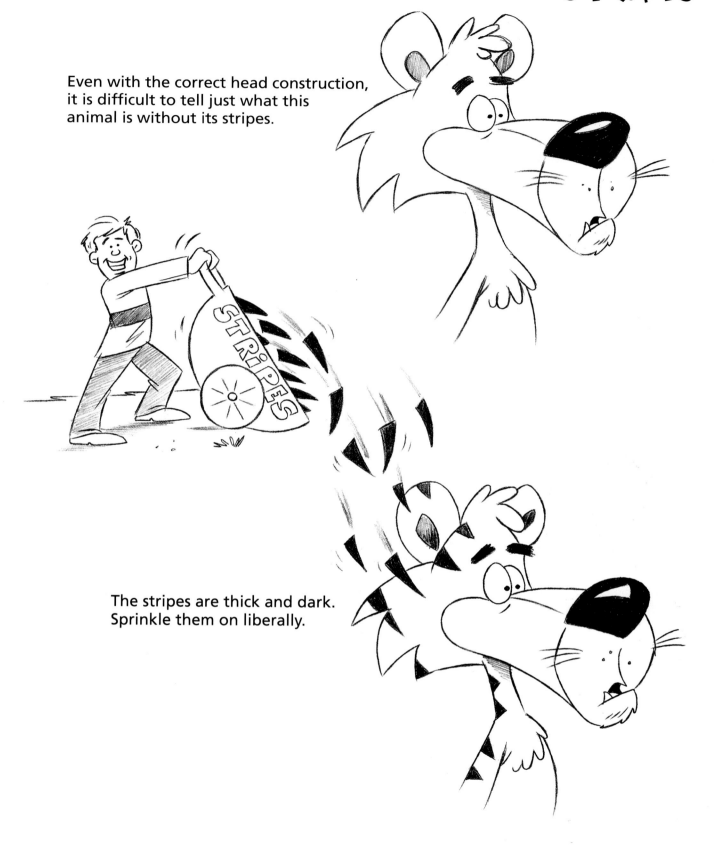

Even with the correct head construction, it is difficult to tell just what this animal is without its stripes.

The stripes are thick and dark. Sprinkle them on liberally.

MACHO TIGER

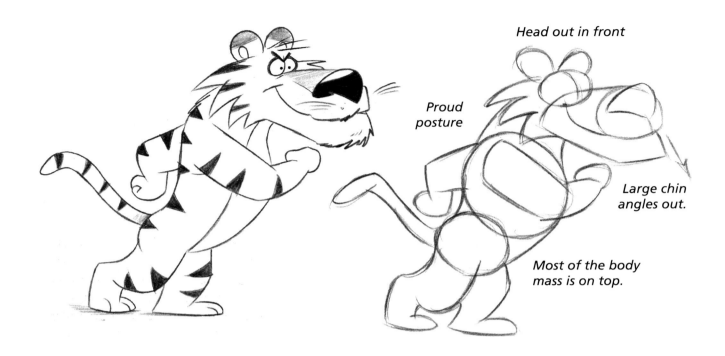

Head out in front

Proud posture

Large chin angles out.

Most of the body mass is on top.

COWARDLY TIGER

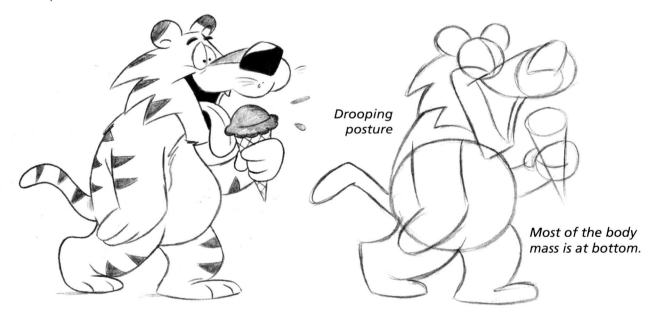

Drooping posture

Most of the body mass is at bottom.

ADVANCED TIGER HEADS

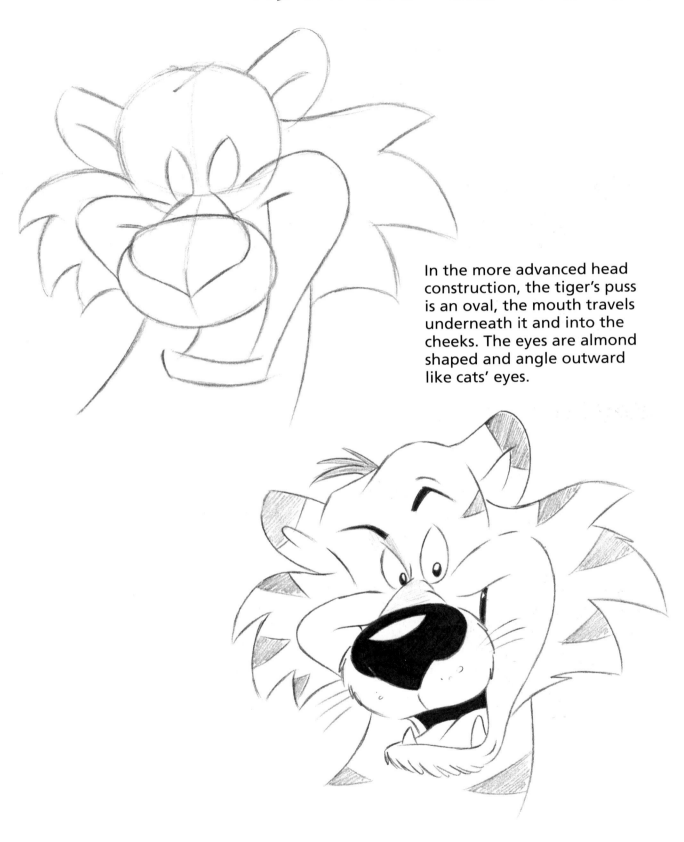

In the more advanced head construction, the tiger's puss is an oval, the mouth travels underneath it and into the cheeks. The eyes are almond shaped and angle outward like cats' eyes.

ADVANCED TIGER BODY

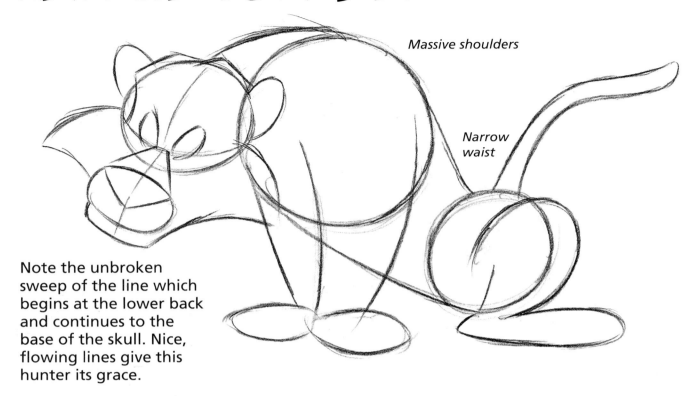

Massive shoulders

Narrow waist

Note the unbroken sweep of the line which begins at the lower back and continues to the base of the skull. Nice, flowing lines give this hunter its grace.

Because the arms are supporting most of the body weight in this pose, the shoulders are pushed up higher.

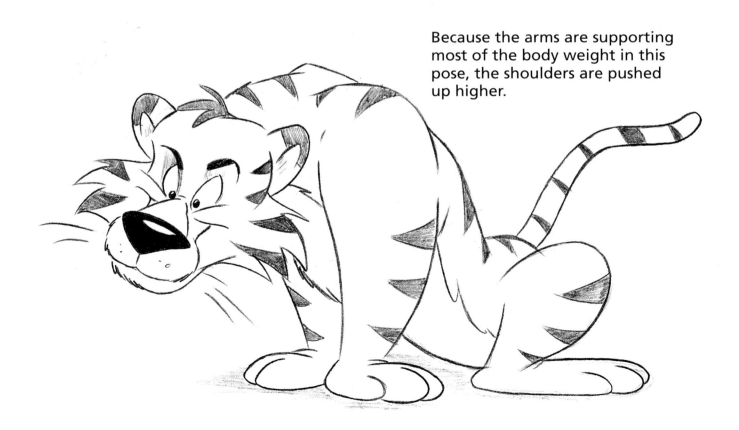

The predatory cartoon tiger walks on all fours while stalking its prey.

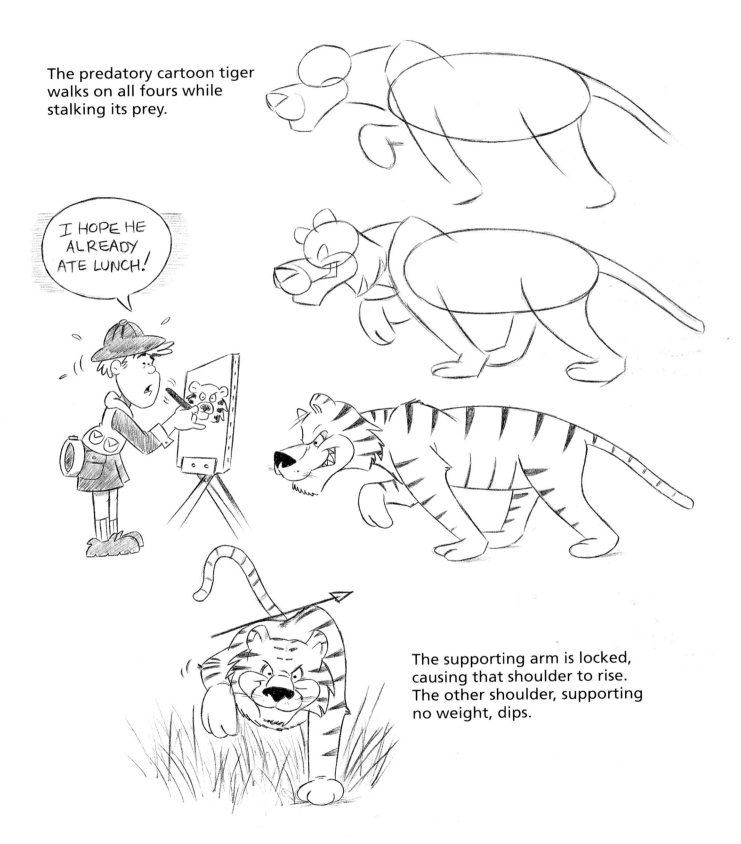

I HOPE HE ALREADY ATE LUNCH!

The supporting arm is locked, causing that shoulder to rise. The other shoulder, supporting no weight, dips.

TiGER POSES

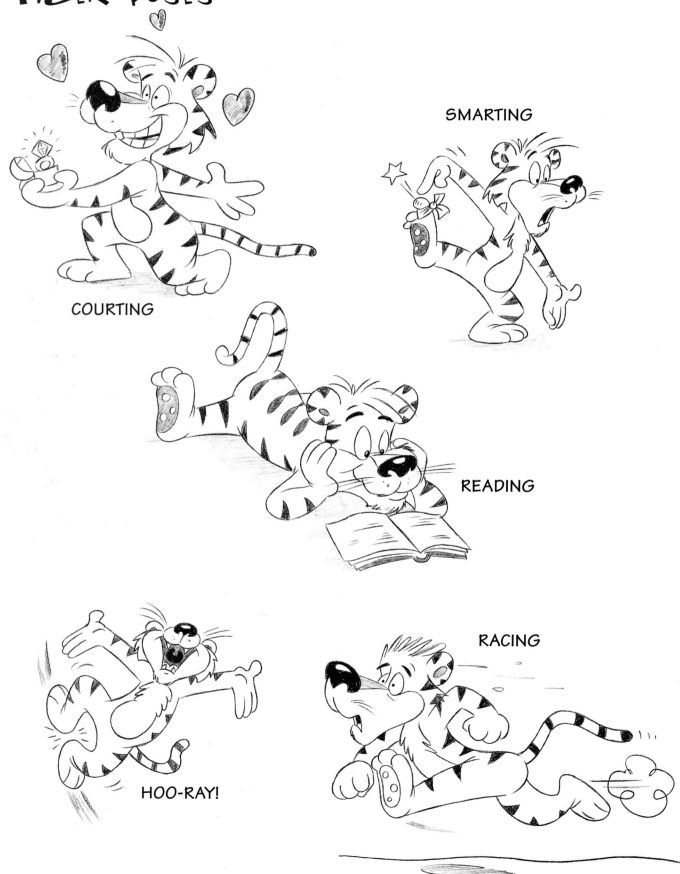

COURTING

SMARTING

READING

HOO-RAY!

RACING

"Playful" is the operative word.

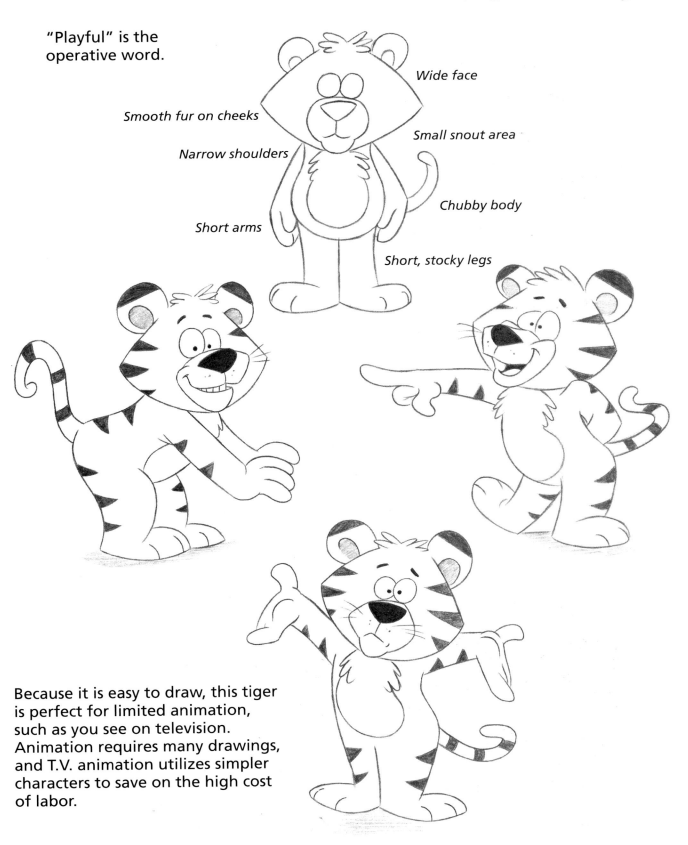

Wide face

Smooth fur on cheeks

Small snout area

Narrow shoulders

Chubby body

Short arms

Short, stocky legs

Because it is easy to draw, this tiger is perfect for limited animation, such as you see on television. Animation requires many drawings, and T.V. animation utilizes simpler characters to save on the high cost of labor.

SHARKS

DRAWiNG SHARK TEETH

Empty mouth

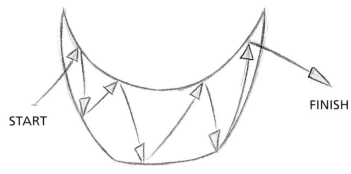

START

FINISH

The teeth are drawn
as a continuous line.

I JUST GOT TO GET A STAND-IN!

A ridge appears on the
shark's upper lip when its
mouth opens to bite.

BASIC SHARK

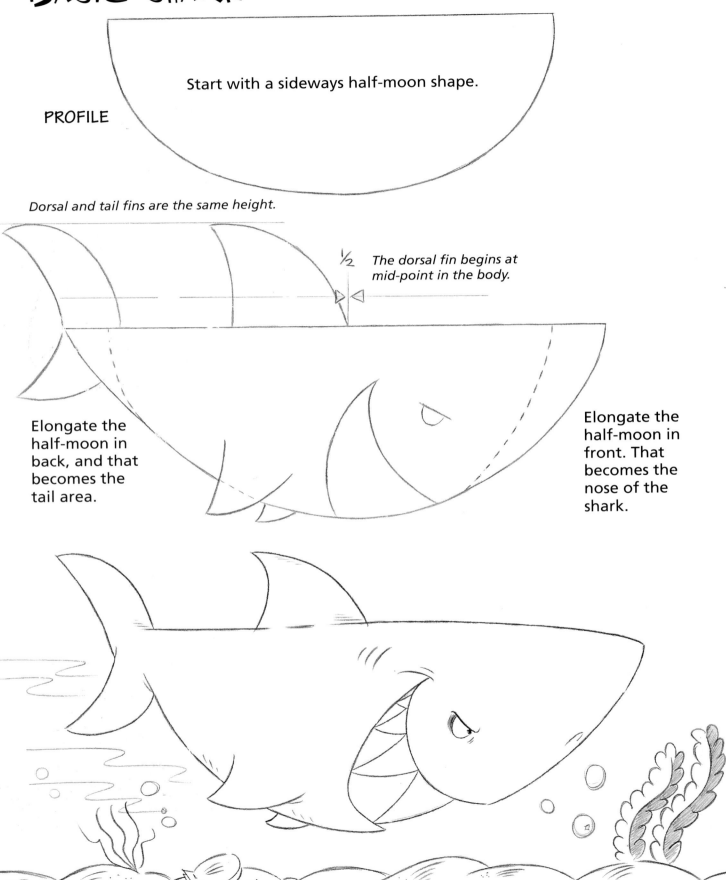

PROFILE

Start with a sideways half-moon shape.

Dorsal and tail fins are the same height.

½ The dorsal fin begins at mid-point in the body.

Elongate the half-moon in back, and that becomes the tail area.

Elongate the half-moon in front. That becomes the nose of the shark.

FRONT VIEW

In this view, the shark is severely foreshortened, so we do not see the tail.

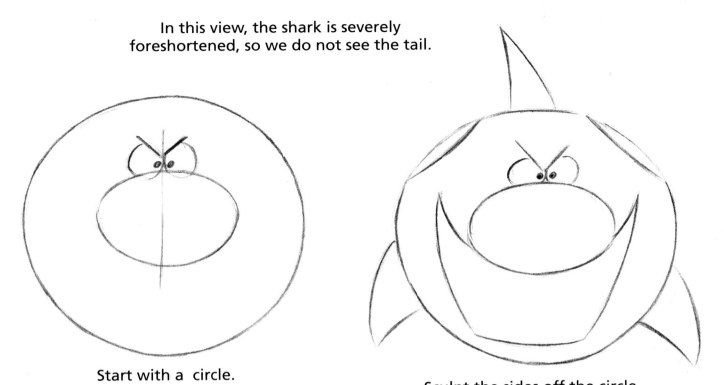

Start with a circle.

Sculpt the sides off the circle.

Tilting the dorsal fin to one side helps to give this character an "attitude."

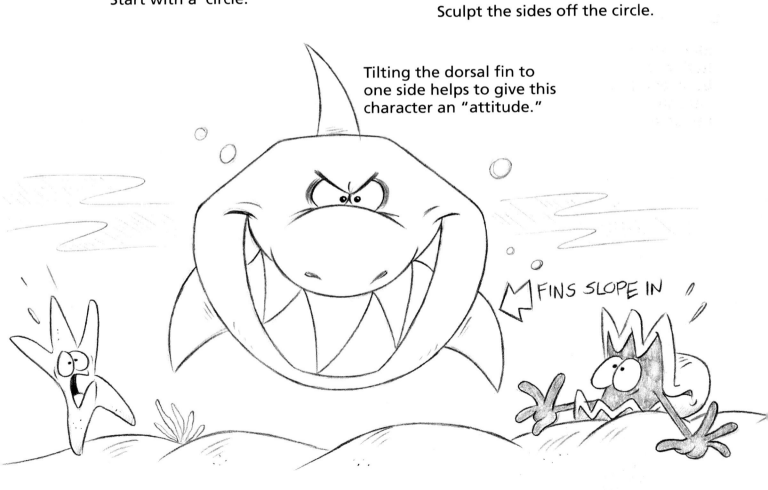

FINS SLOPE IN

SHARK MOVEMENT

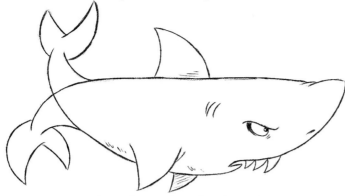

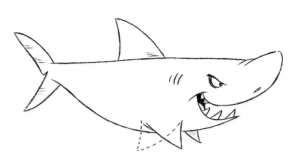

In animation, the shark swims by moving its tail while the rest of its body remains relatively still.

Subtle differences in fin positions can convey attitudes. Forward fins are aggressive.

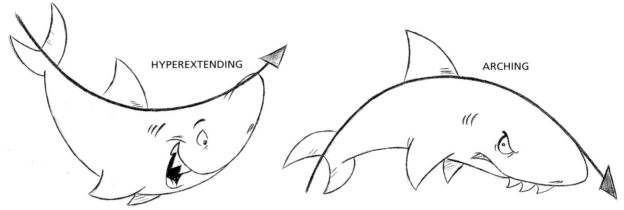

HYPEREXTENDING

ARCHING

Let the line of the back dictate the flow of the pose.

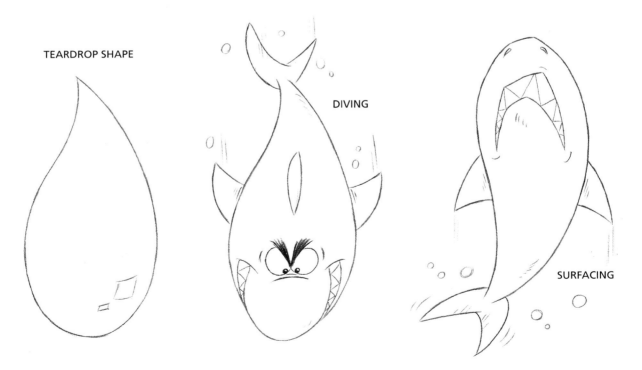

TEARDROP SHAPE

DIVING

SURFACING

SHARK FINS AS HANDS

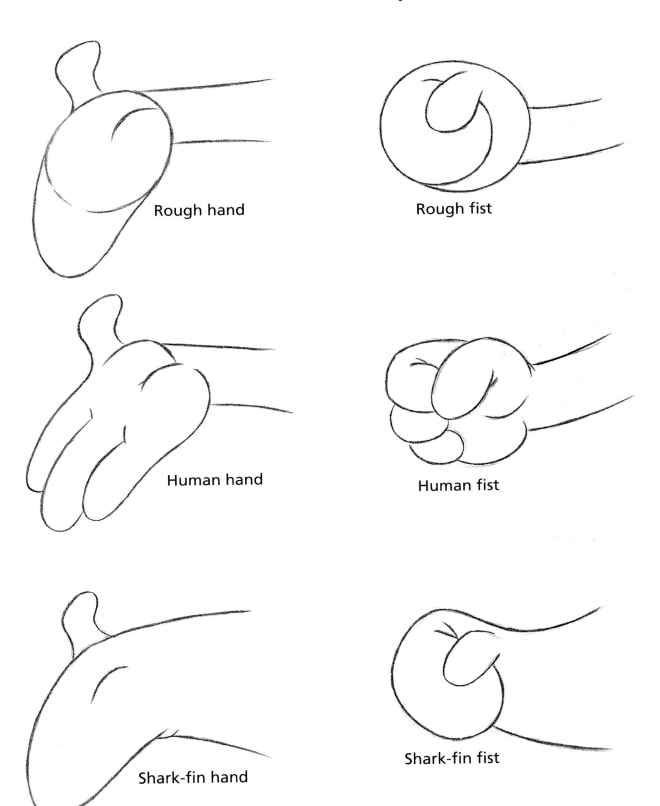

Rough hand

Rough fist

Human hand

Human fist

Shark-fin hand

Shark-fin fist

SHARK POSES

Note how the fins can be
used as hands and feet.

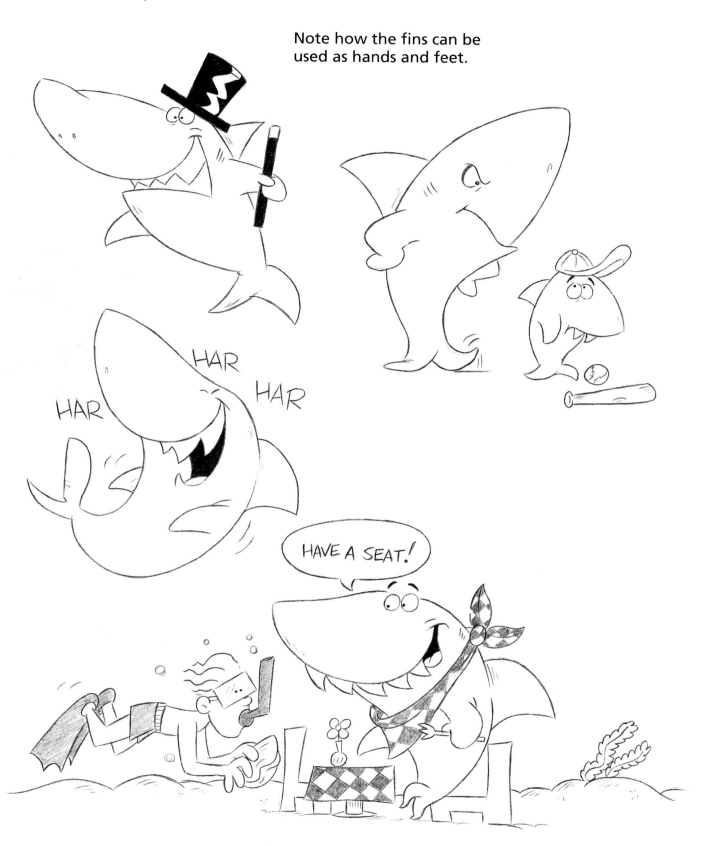

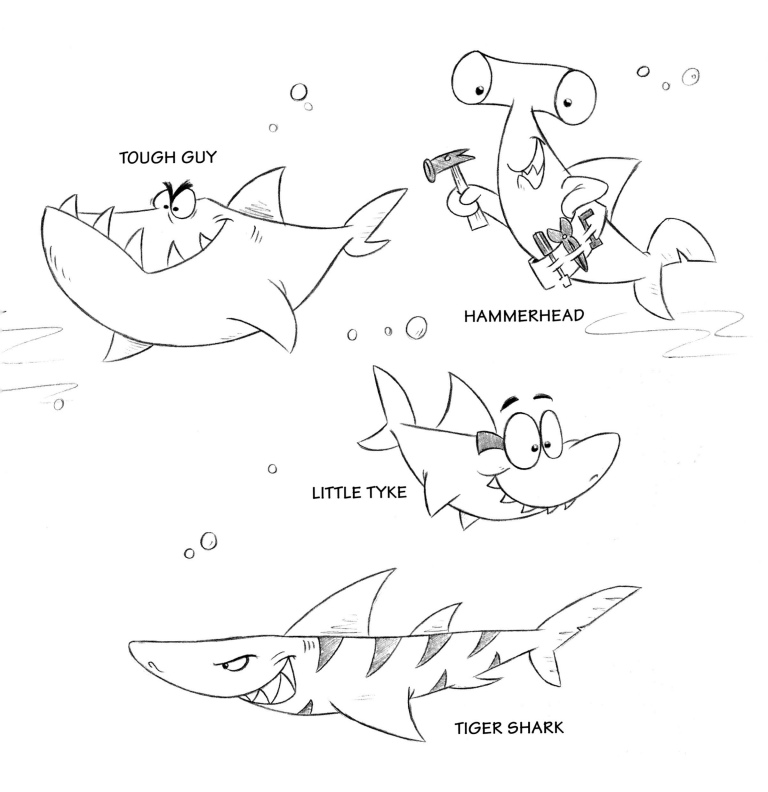

TOUGH GUY

HAMMERHEAD

LITTLE TYKE

TIGER SHARK

HORSES

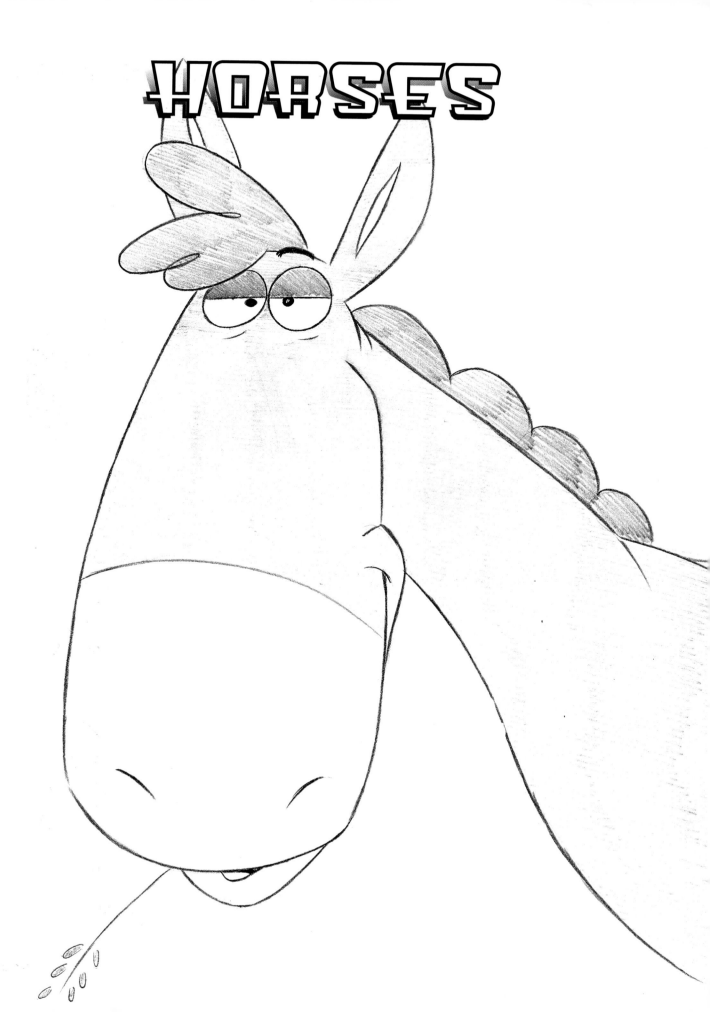

SIMPLE STANDING HORSE

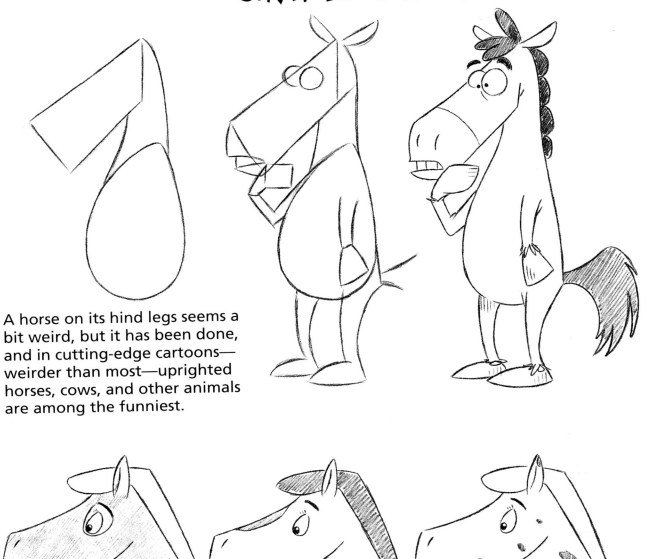

A horse on its hind legs seems a bit weird, but it has been done, and in cutting-edge cartoons—weirder than most—uprighted horses, cows, and other animals are among the funniest.

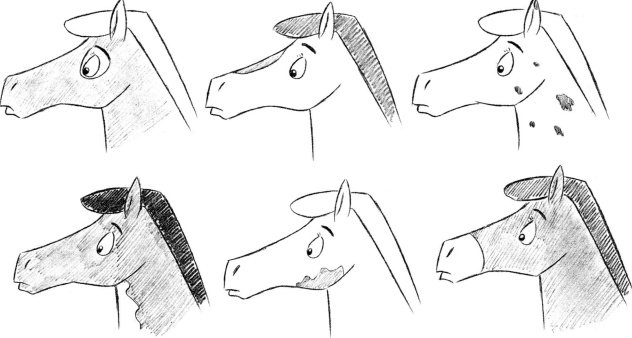

MARKINGS
Markings are a must on horses. Combine several markings to create unique identities. Here are some examples.

HORSE ON ALL FOURS

The funny-looking horse is a popular and broadly humorous cartoon character.

Start with a sausage shape.

Overlapping eyes

Bushy tail

Bony shoulder and hip joints stick out.

Skinny neck

Human knee joints

Oversized hooves

TRADITIONAL HORSE

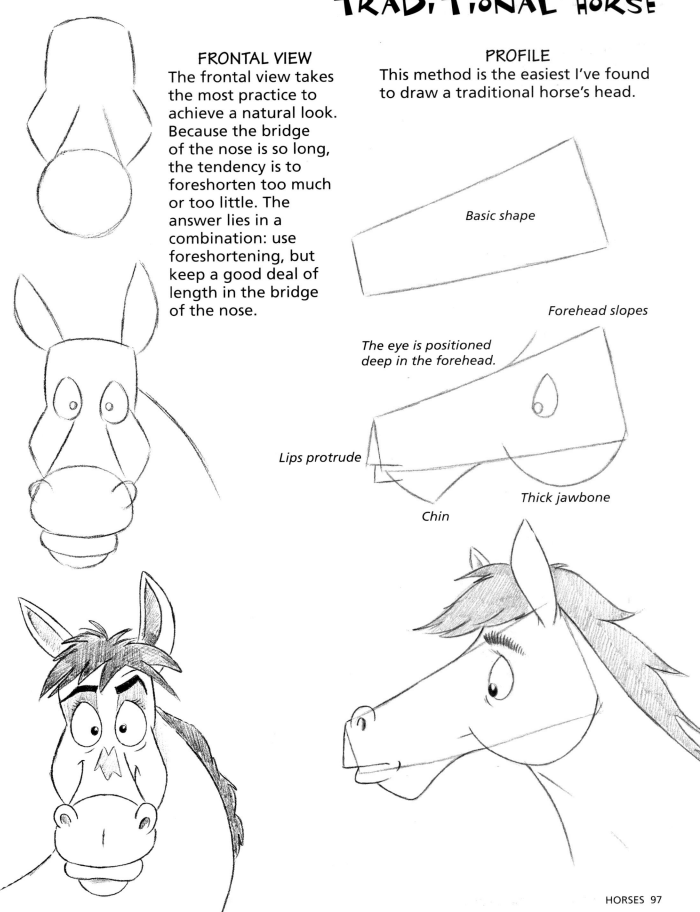

FRONTAL VIEW
The frontal view takes the most practice to achieve a natural look. Because the bridge of the nose is so long, the tendency is to foreshorten too much or too little. The answer lies in a combination: use foreshortening, but keep a good deal of length in the bridge of the nose.

PROFILE
This method is the easiest I've found to draw a traditional horse's head.

Basic shape

Forehead slopes

The eye is positioned deep in the forehead.

Lips protrude

Chin

Thick jawbone

HORSES' TEETH

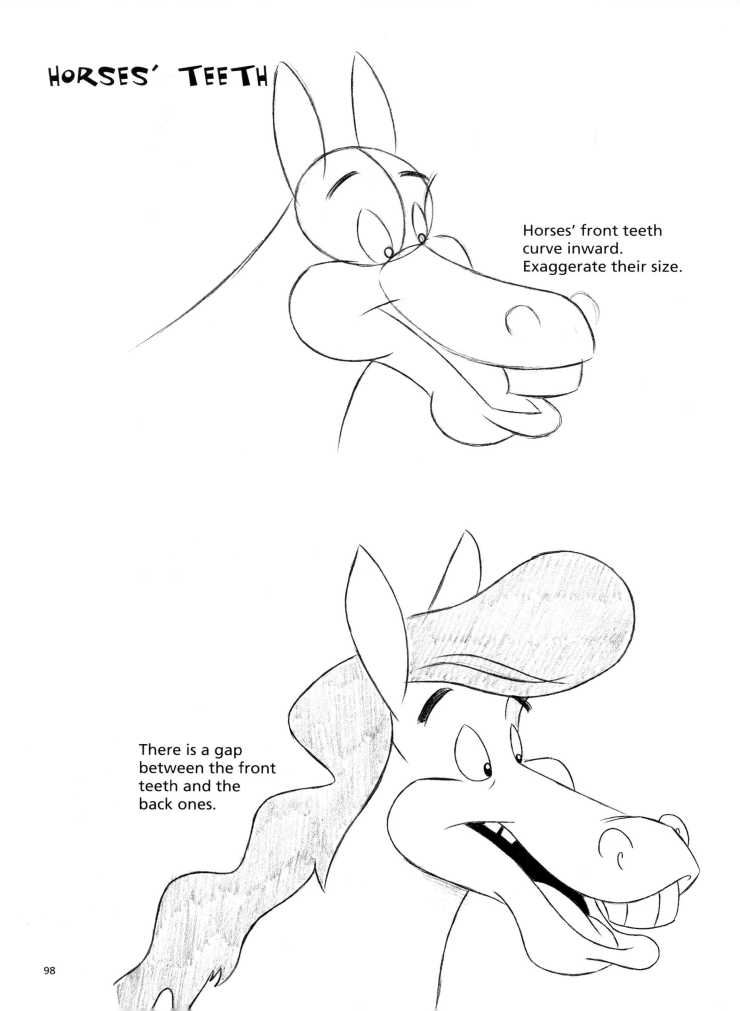

Horses' front teeth
curve inward.
Exaggerate their size.

There is a gap
between the front
teeth and the
back ones.

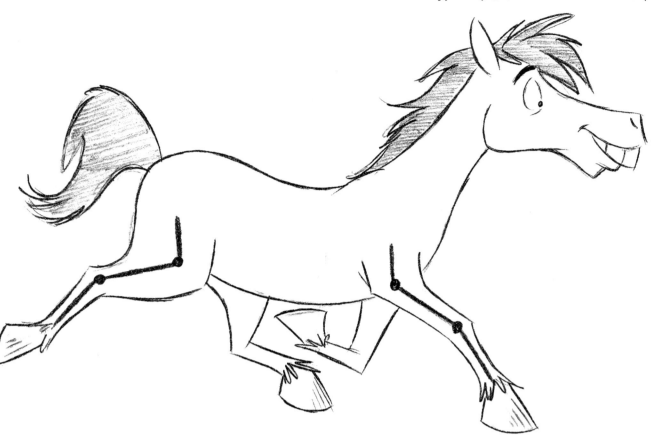

The horse's joint configuration is similar to the dog's. Study these diagrams. Become aware of the way the bones attach, and your cartoons will take on more authority.

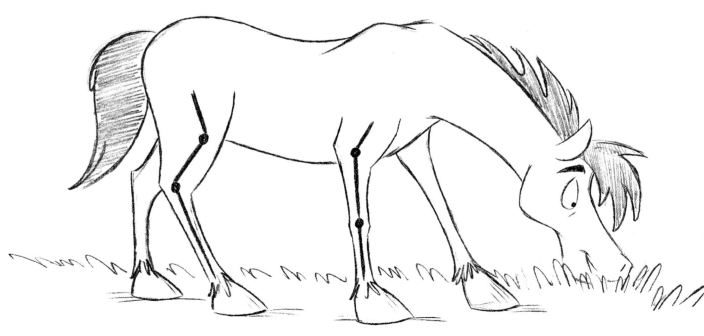

TORSO

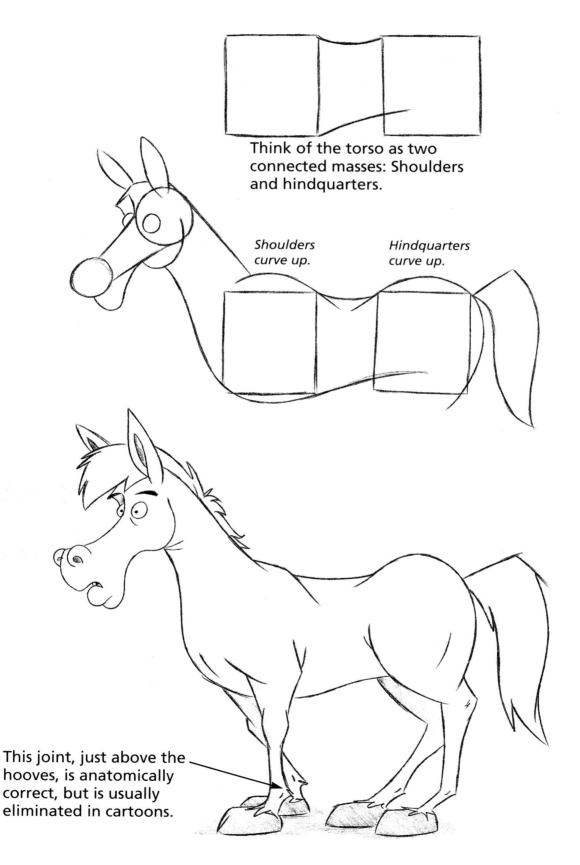

Think of the torso as two connected masses: Shoulders and hindquarters.

Shoulders curve up.

Hindquarters curve up.

This joint, just above the hooves, is anatomically correct, but is usually eliminated in cartoons.

MYTHICAL HORSE

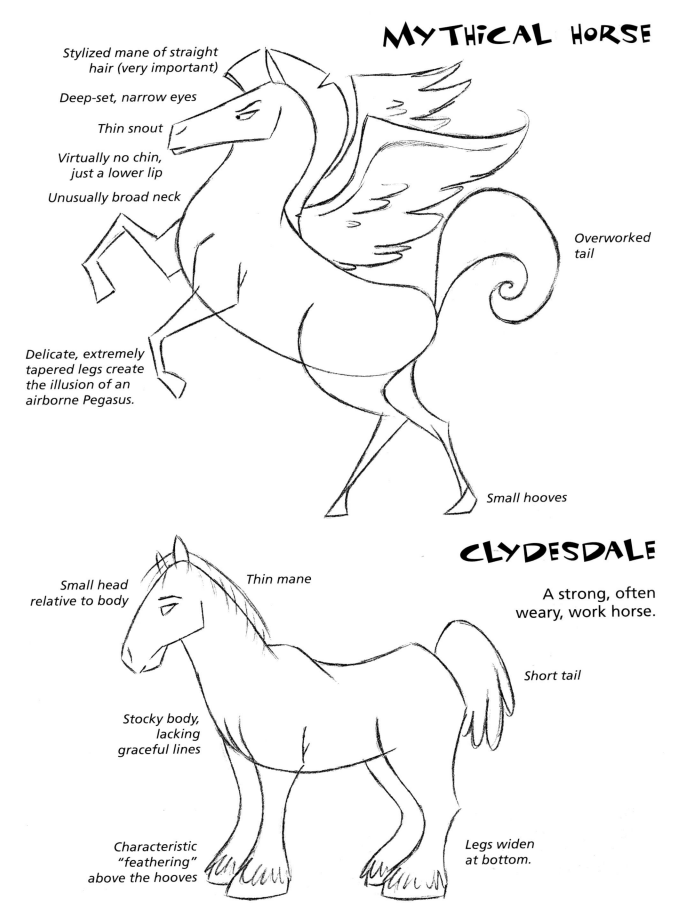

Stylized mane of straight hair (very important)

Deep-set, narrow eyes

Thin snout

Virtually no chin, just a lower lip

Unusually broad neck

Overworked tail

Delicate, extremely tapered legs create the illusion of an airborne Pegasus.

Small hooves

CLYDESDALE

A strong, often weary, work horse.

Small head relative to body

Thin mane

Short tail

Stocky body, lacking graceful lines

Characteristic "feathering" above the hooves

Legs widen at bottom.

STRONG HORSE

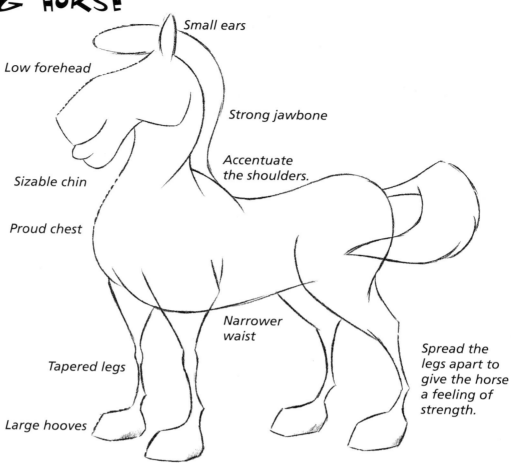

Small ears

Low forehead

Strong jawbone

Accentuate
the shoulders.

Sizable chin

Proud chest

Narrower
waist

Spread the
legs apart to
give the horse
a feeling of
strength.

Tapered legs

Large hooves

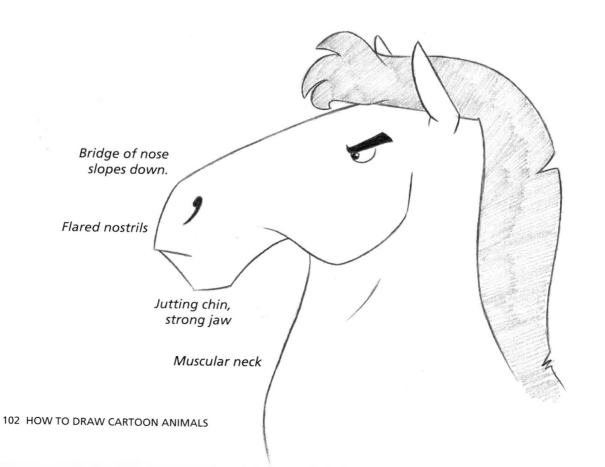

Bridge of nose
slopes down.

Flared nostrils

Jutting chin,
strong jaw

Muscular neck

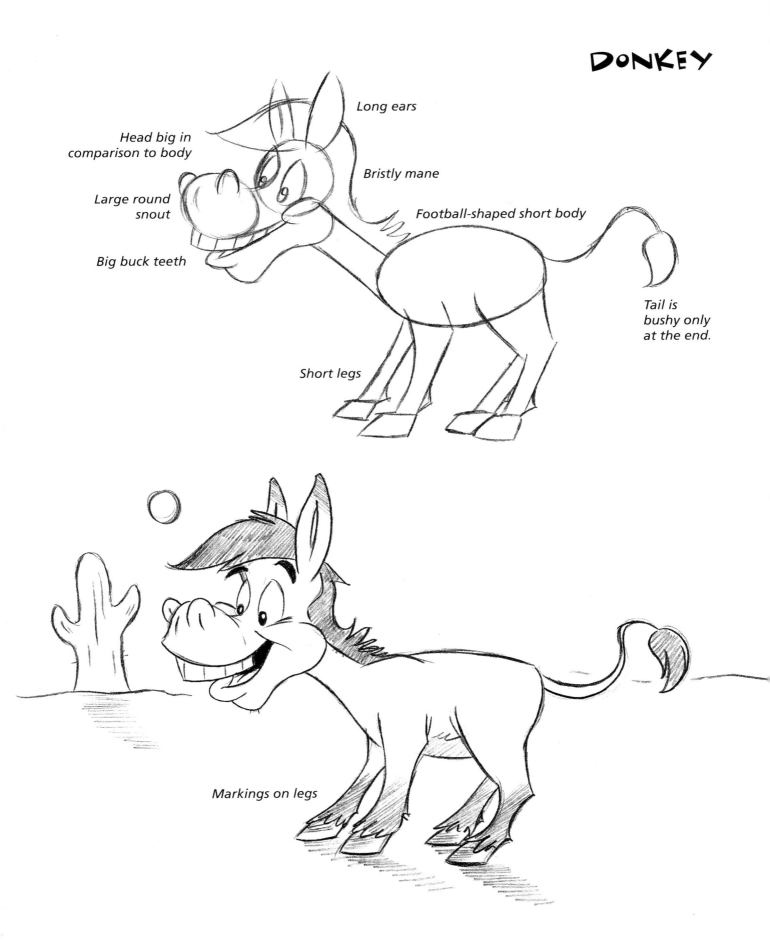

DONKEY

Long ears

Head big in comparison to body

Bristly mane

Large round snout

Football-shaped short body

Big buck teeth

Tail is bushy only at the end.

Short legs

Markings on legs

BIRDS

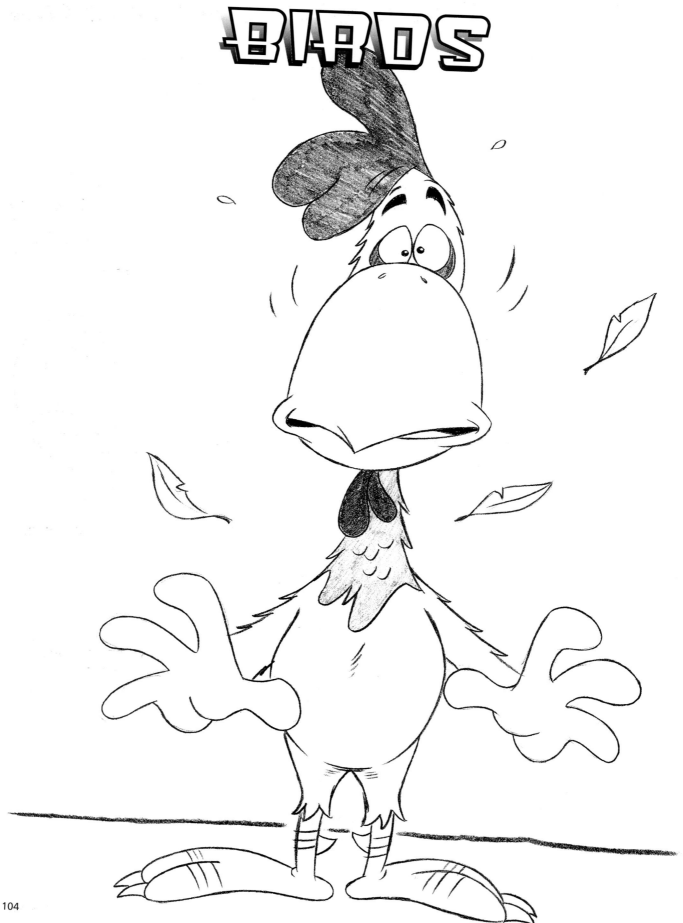

BASIC BIRD CONSTRUCTION

Think of the beak as a cone shape attached to the skull.

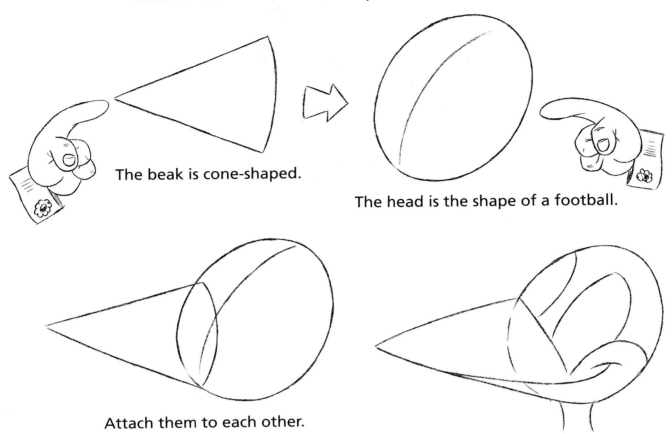

The beak is cone-shaped.

The head is the shape of a football.

Attach them to each other.

Extend beak to form cheek area.

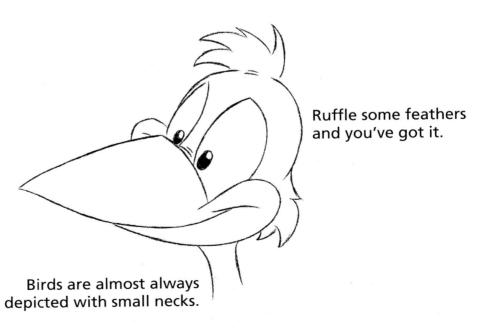

Ruffle some feathers and you've got it.

Birds are almost always depicted with small necks.

THE DUCK: A CARTOON CLASSIC

The duck is perhaps the most popular cartoon bird of all time. The two most important elements in giving the duck its identity are its beak and feet.

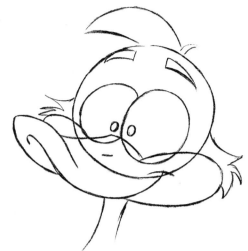

The beak is drawn with a curve. In a three-quarter view, it appears to circle back under itself.

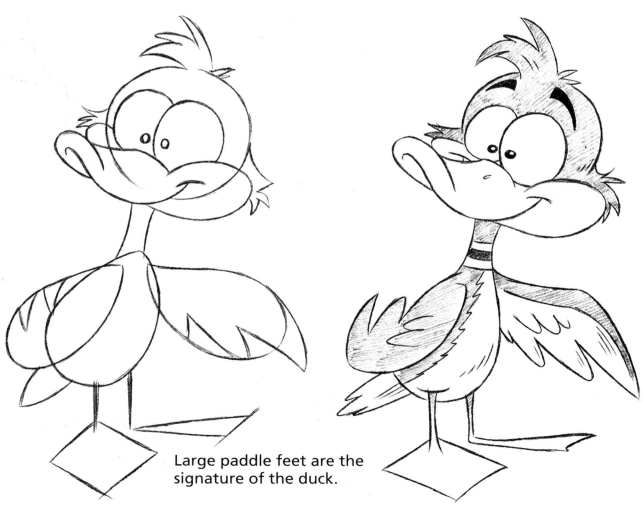

Large paddle feet are the signature of the duck.

DUCK BiLLS

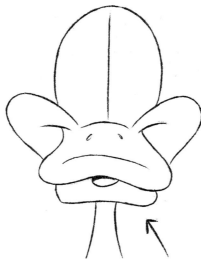

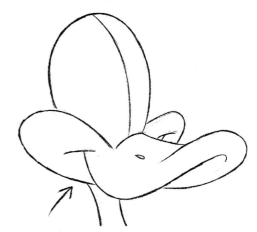

3/4 left view: Study the "smile lines" that define the underside of the bill—they curve and create the lift of the tip of the bill.

Front: The lower bill is thick and prominent.

3/4 right: The cheek often disappears under the mouth.

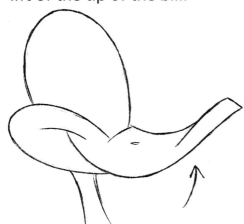

Profile: The curl of the 3/4 view doesn't show from the side.

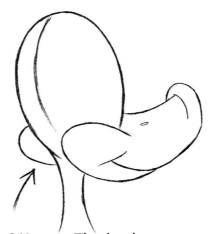

3/4 rear: The back of the cheek shows.

Rear

Ducks are fun to draw —and they make great characters —but they take some practice because the bill's curve is drawn differently as the position of the head changes. These are the major head positions —give them all a try.

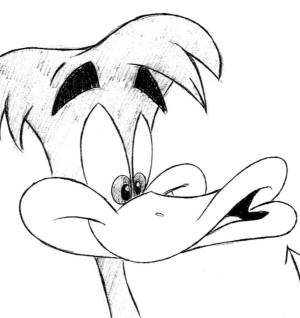

The lower bill becomes a lip you can elongate to make goofy expressions.

CUTE DUCKS

Certain traits make this little duck look cute.

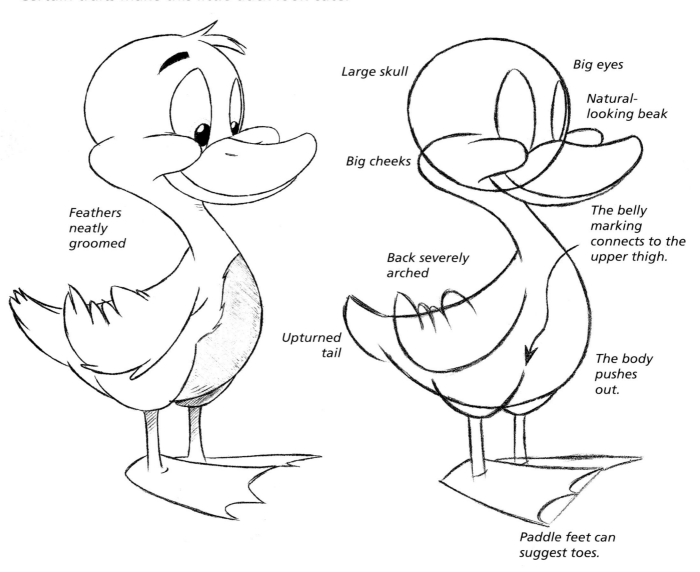

Feathers neatly groomed

Upturned tail

Large skull

Big cheeks

Back severely arched

Big eyes

Natural-looking beak

The belly marking connects to the upper thigh.

The body pushes out.

Paddle feet can suggest toes.

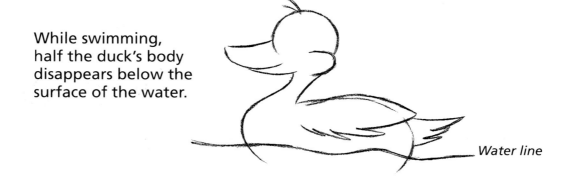

While swimming, half the duck's body disappears below the surface of the water.

Water line

BIRD CONSTRUCTION

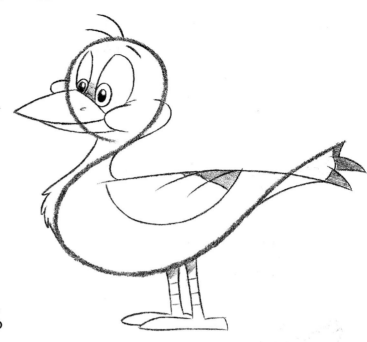

Use graceful lines! In the side and 3/4 view, the line of the bird flows easily from top to bottom. Try to achieve this "single line" quality in your drawings.

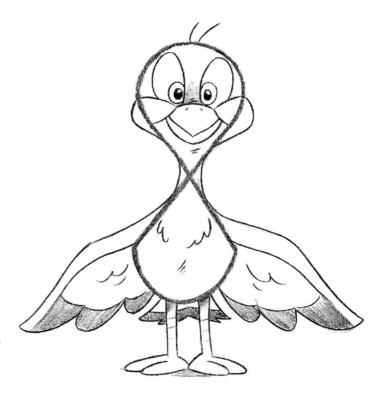

The front view is less flattering, yet the overall shape can still be indicated with a single line.

WiNGS iN FLiGHT

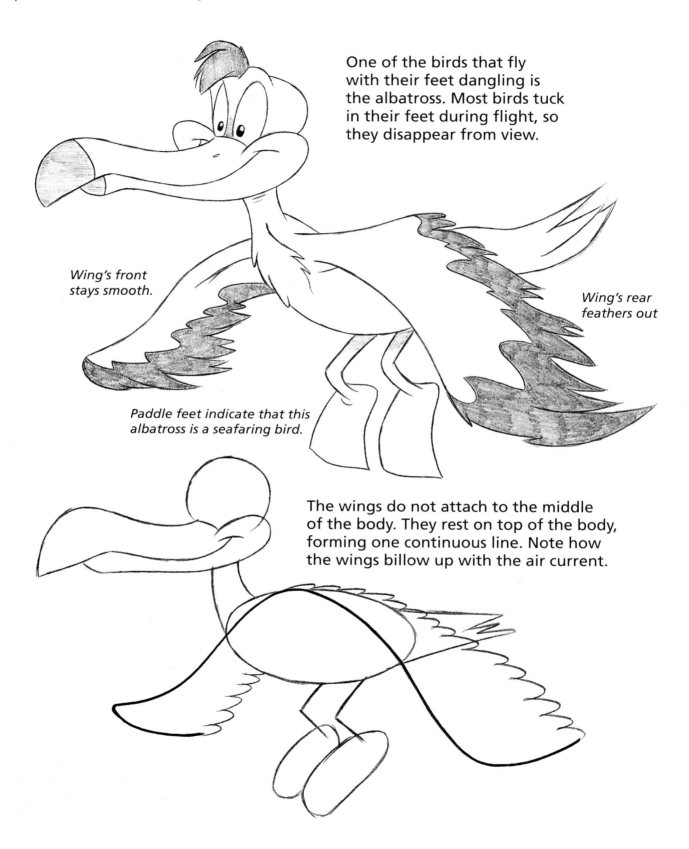

One of the birds that fly with their feet dangling is the albatross. Most birds tuck in their feet during flight, so they disappear from view.

Wing's front stays smooth.

Wing's rear feathers out

Paddle feet indicate that this albatross is a seafaring bird.

The wings do not attach to the middle of the body. They rest on top of the body, forming one continuous line. Note how the wings billow up with the air current.

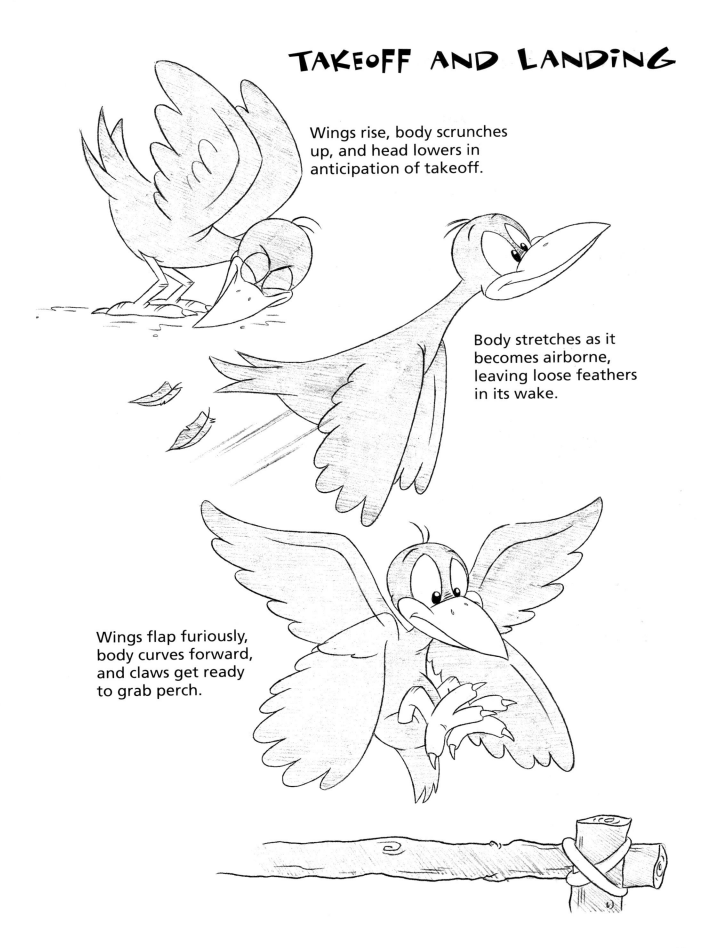

Wings rise, body scrunches up, and head lowers in anticipation of takeoff.

Body stretches as it becomes airborne, leaving loose feathers in its wake.

Wings flap furiously, body curves forward, and claws get ready to grab perch.

BACKYARD BiRDS

The bluebird, sparrow, and robin can all be drawn as a generic backyard bird.

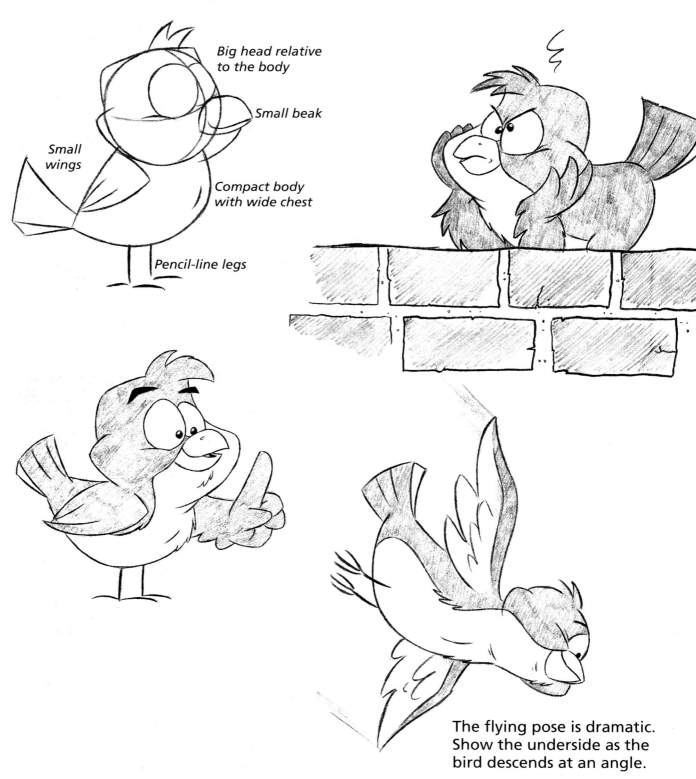

Big head relative to the body

Small beak

Small wings

Compact body with wide chest

Pencil-line legs

The flying pose is dramatic. Show the underside as the bird descends at an angle.

The owl is another popular bird, usually cast in cartoons as an educated, sometimes pompous, colleague. It is not usually the star, but a supporting member of the cast.

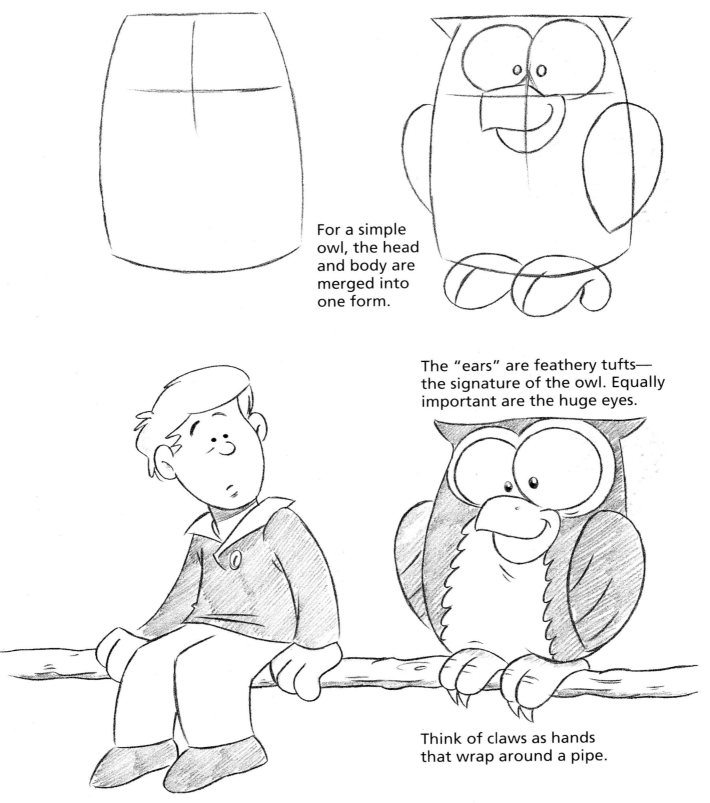

For a simple owl, the head and body are merged into one form.

The "ears" are feathery tufts—the signature of the owl. Equally important are the huge eyes.

Think of claws as hands that wrap around a pipe.

CONTEMPORARY OWL

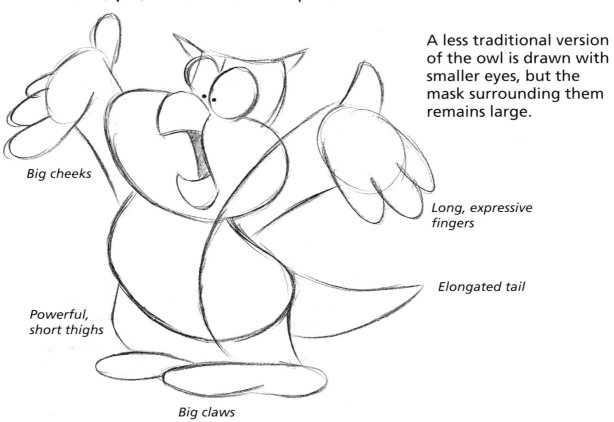

A less traditional version of the owl is drawn with smaller eyes, but the mask surrounding them remains large.

Big cheeks

Long, expressive fingers

Elongated tail

Powerful, short thighs

Big claws

OWL EYES
To make an owl appear wise, draw the irises around the pupils.

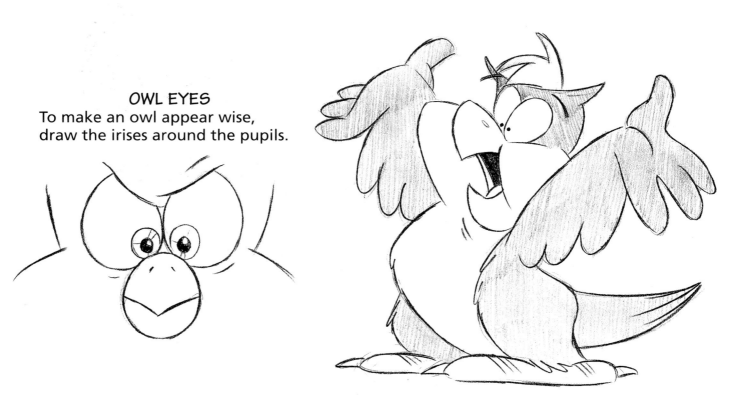

OWL EXPRESSIONS

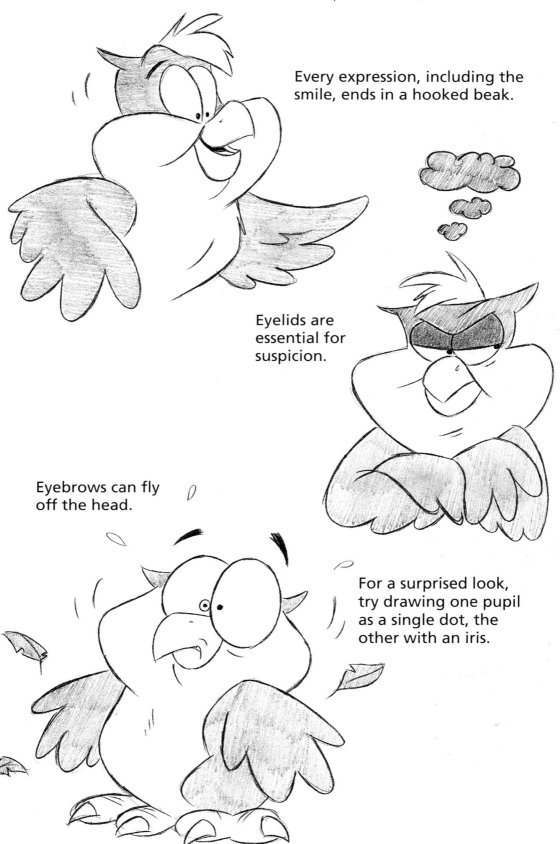

Every expression, including the smile, ends in a hooked beak.

Eyelids are essential for suspicion.

Eyebrows can fly off the head.

For a surprised look, try drawing one pupil as a single dot, the other with an iris.

PENGUINS

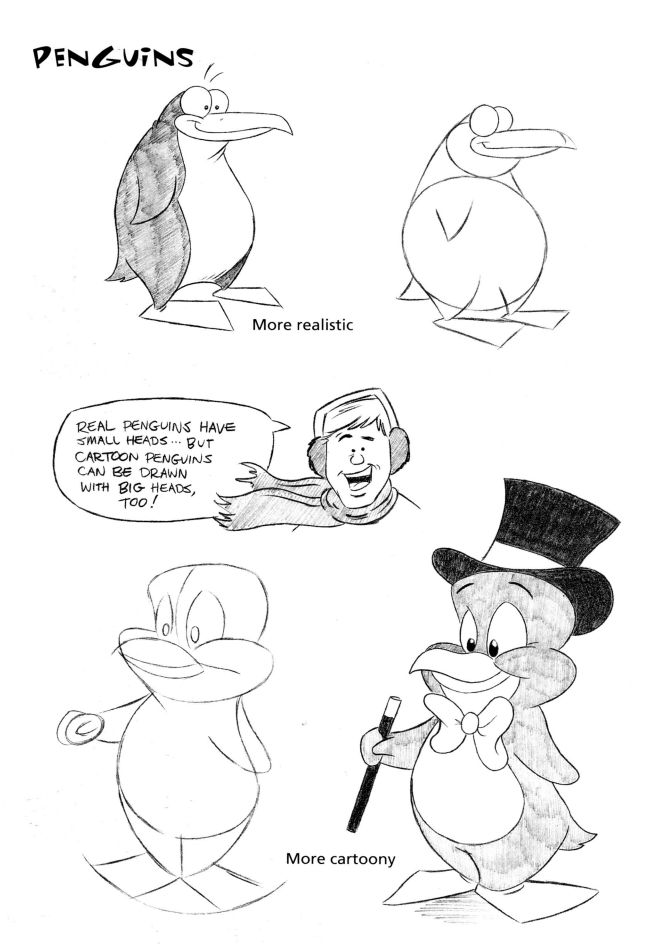

More realistic

REAL PENGUINS HAVE SMALL HEADS... BUT CARTOON PENGUINS CAN BE DRAWN WITH BIG HEADS, TOO!

More cartoony

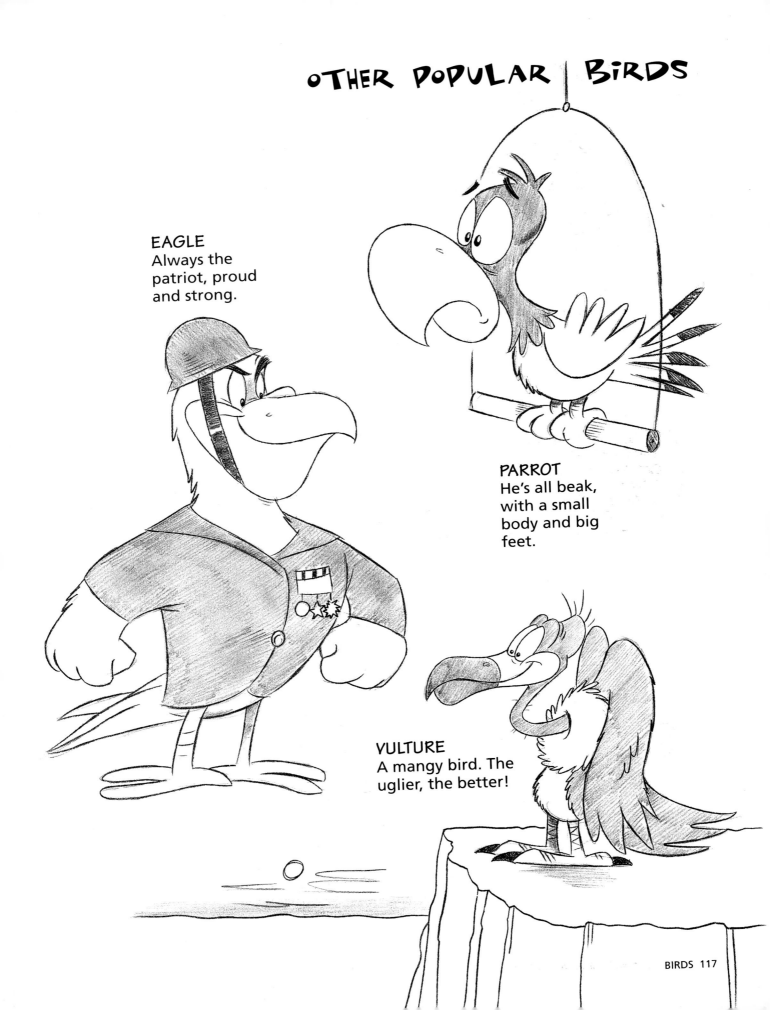

OTHER POPULAR BIRDS

EAGLE
Always the patriot, proud and strong.

PARROT
He's all beak, with a small body and big feet.

VULTURE
A mangy bird. The uglier, the better!

OTHER CRITTERS

SSSSSNAKES

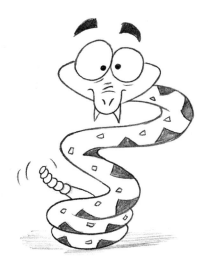

VIPER
Note the flat head and widely spaced eyes.

RATTLER
Note the Aztec-style markings and, of course, the rattle on the tail.

COBRA
The hood is the signature of this reptile.

Goofy cobra

SCREWBALL WOLF

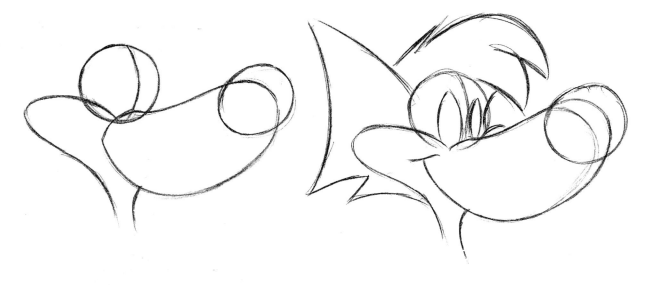

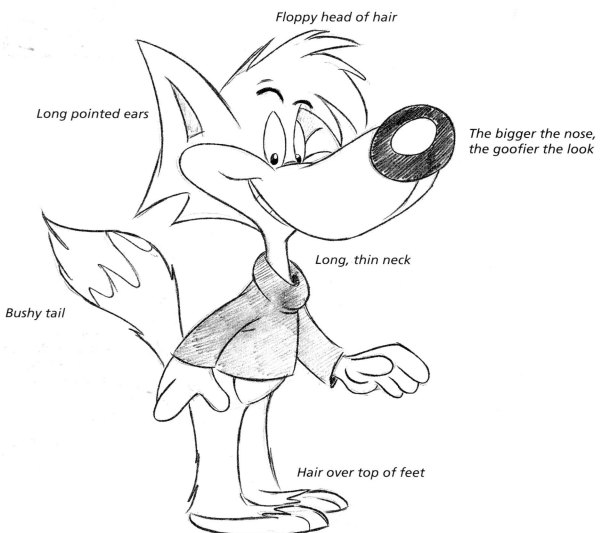

Floppy head of hair

Long pointed ears

The bigger the nose,
the goofier the look

Long, thin neck

Bushy tail

Hair over top of feet

VILLAINOUS WOLF

Animal villains are often drawn on all fours.
After all, it gives them a wild, feral look.

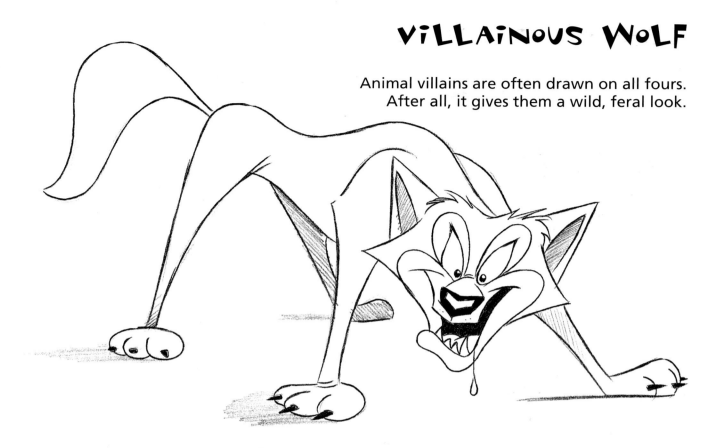

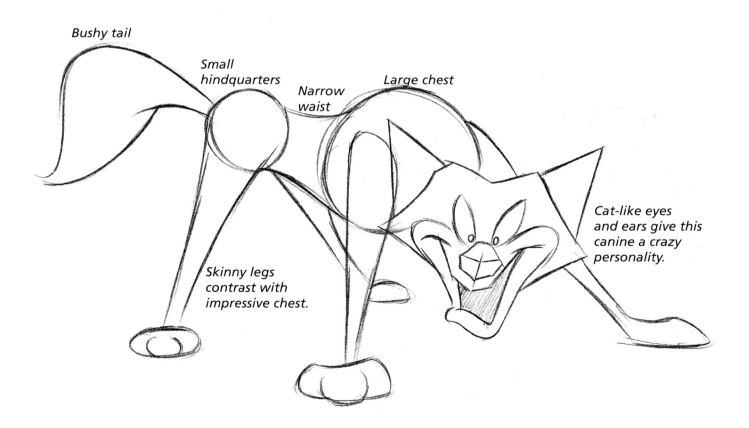

Bushy tail

Small hindquarters

Narrow waist

Large chest

Skinny legs contrast with impressive chest.

Cat-like eyes and ears give this canine a crazy personality.

BUNNY RABBIT

This cute rabbit sits on its chubby hind legs. It has a small upper body and mitten-like hands. The nose itself can be drawn any size, but the snout is always small.

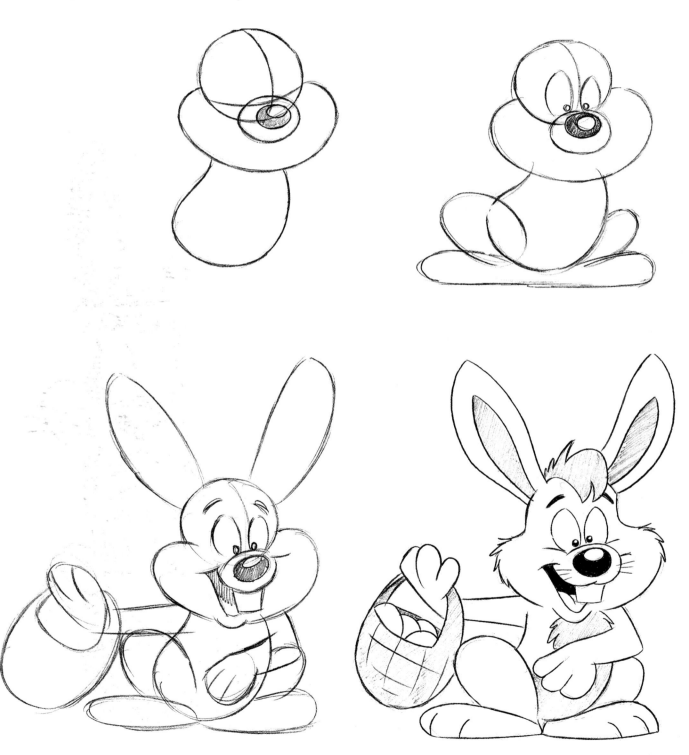

STANDING RABBIT

Extra long ears

Big cheeks

Big snout

Buck teeth

Long torso

Bushy tail

Huge feet

RATS

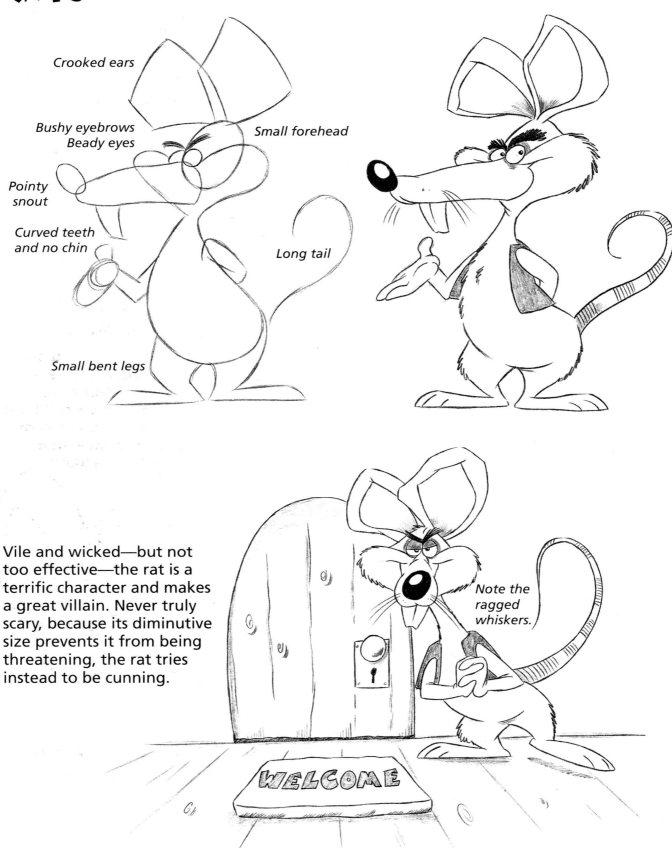

Crooked ears

Bushy eyebrows
Beady eyes

Small forehead

Pointy snout

Curved teeth and no chin

Long tail

Small bent legs

Vile and wicked—but not too effective—the rat is a terrific character and makes a great villain. Never truly scary, because its diminutive size prevents it from being threatening, the rat tries instead to be cunning.

Note the ragged whiskers.

WELCOME

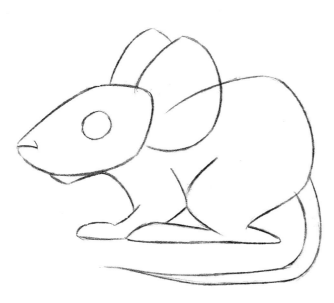

REAL MOUSE

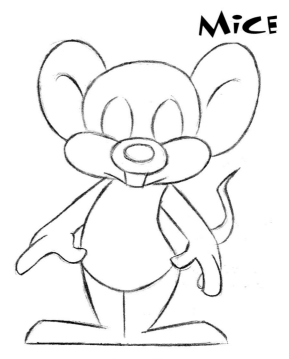

CARTOON MOUSE

Cartoon mouse anatomy, based on that of other cartoons, has little to do with real mouse anatomy. For example, the real mouse doesn't have fat cheeks, but every cartoon mouse has them. It's a cartoon invention which has become the standard.

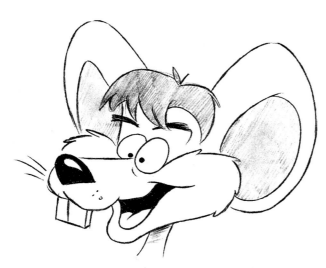

A long-nosed mouse looks scruffier than the short-nosed variety.

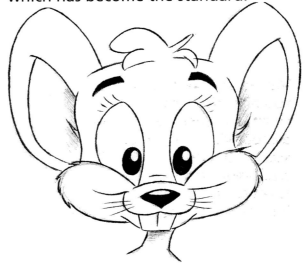

A short-nosed mouse is cuter and younger-looking.

GiRAFFES

The giraffe is one of the oddest-looking creatures. With a long neck and a squat body, the giraffe is a host of physical contradictions. In a cartoon, you want to highlight its awkwardness.

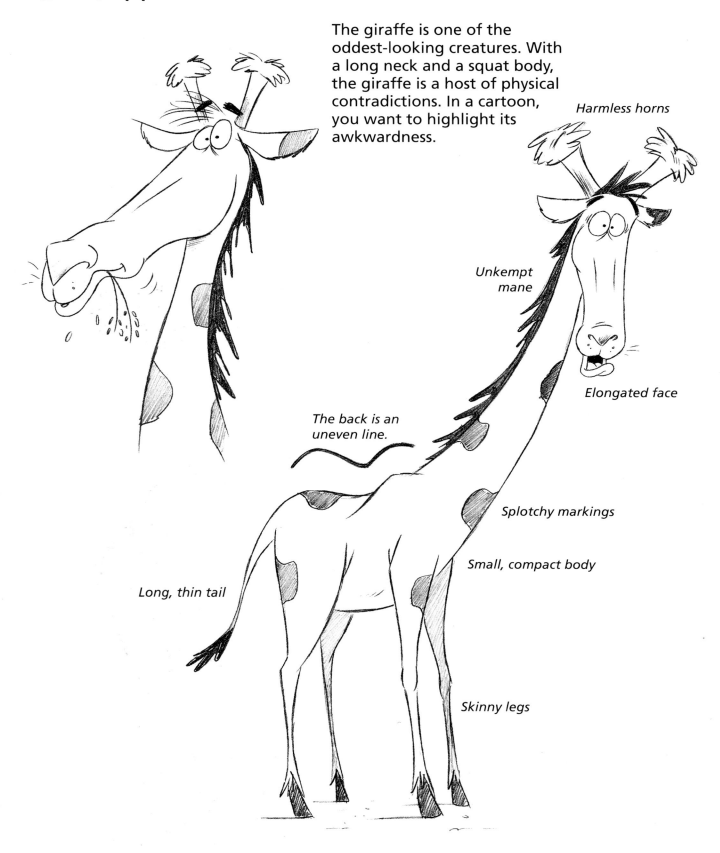

Harmless horns

Unkempt mane

Elongated face

The back is an uneven line.

Splotchy markings

Small, compact body

Long, thin tail

Skinny legs

BULLS

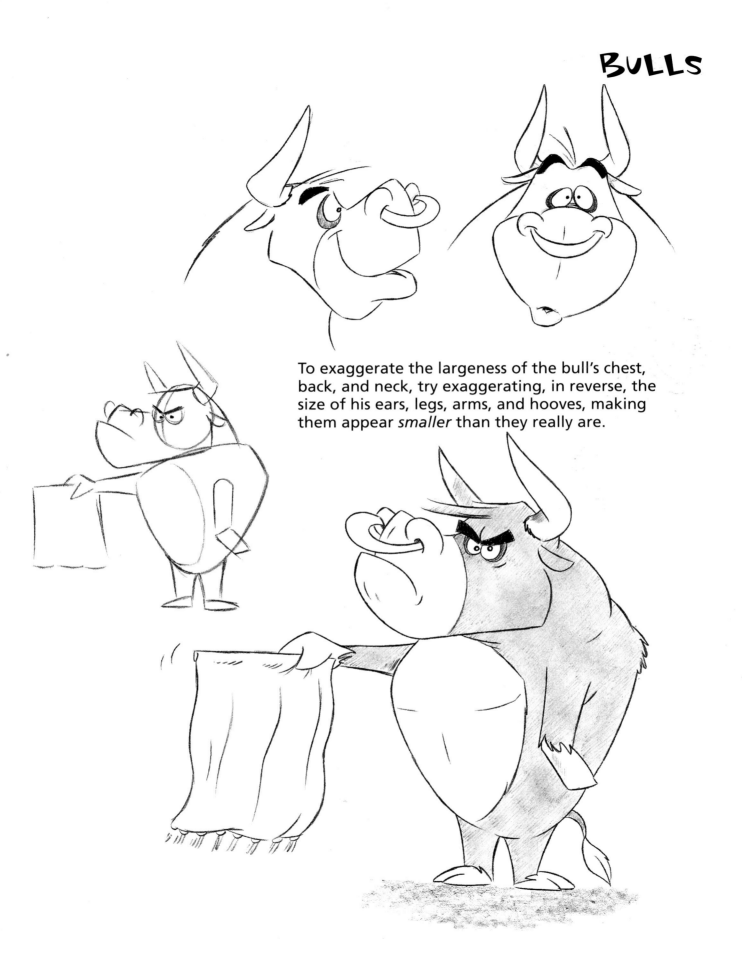

To exaggerate the largeness of the bull's chest, back, and neck, try exaggerating, in reverse, the size of his ears, legs, arms, and hooves, making them appear *smaller* than they really are.

REINDEER

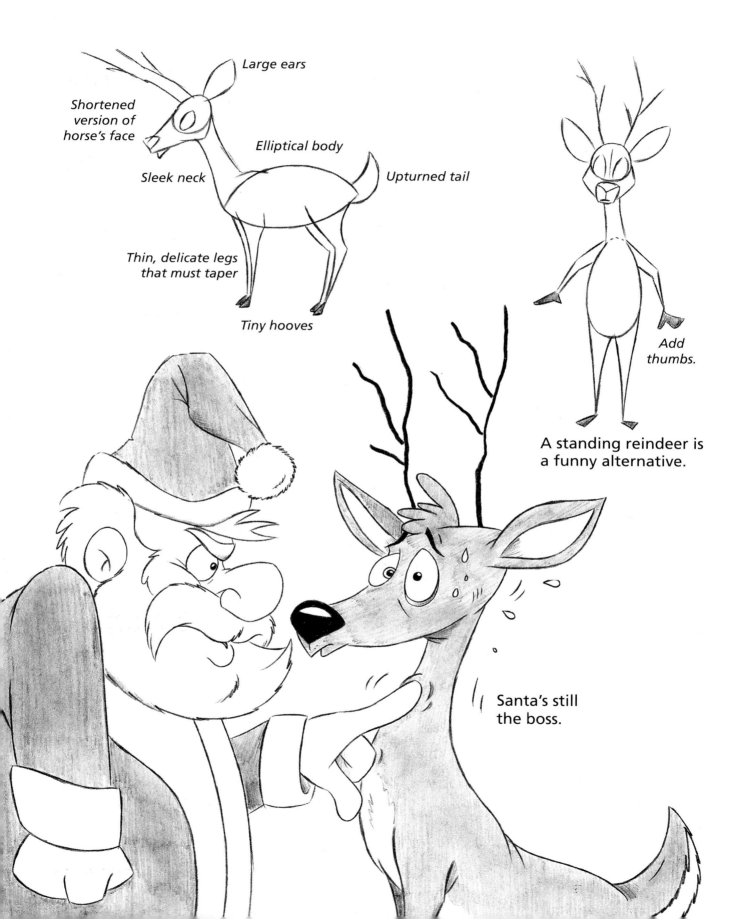

Large ears

Shortened version of horse's face

Elliptical body

Sleek neck

Upturned tail

Thin, delicate legs that must taper

Tiny hooves

Add thumbs.

A standing reindeer is a funny alternative.

Santa's still the boss.

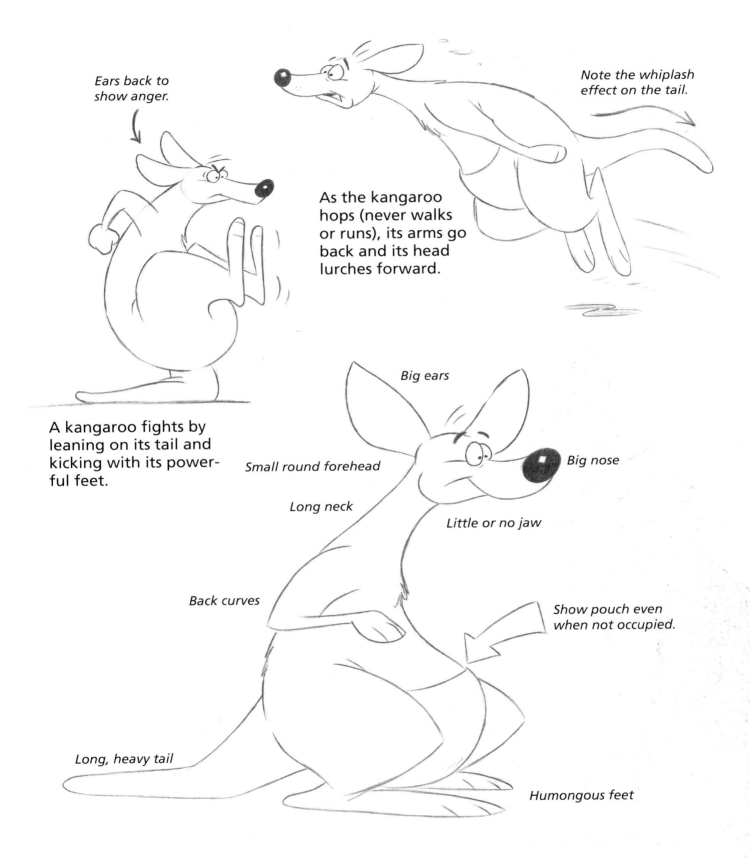

Ears back to show anger.

Note the whiplash effect on the tail.

As the kangaroo hops (never walks or runs), its arms go back and its head lurches forward.

A kangaroo fights by leaning on its tail and kicking with its powerful feet.

Big ears

Small round forehead

Big nose

Long neck

Little or no jaw

Back curves

Show pouch even when not occupied.

Long, heavy tail

Humongous feet

BEAVERS

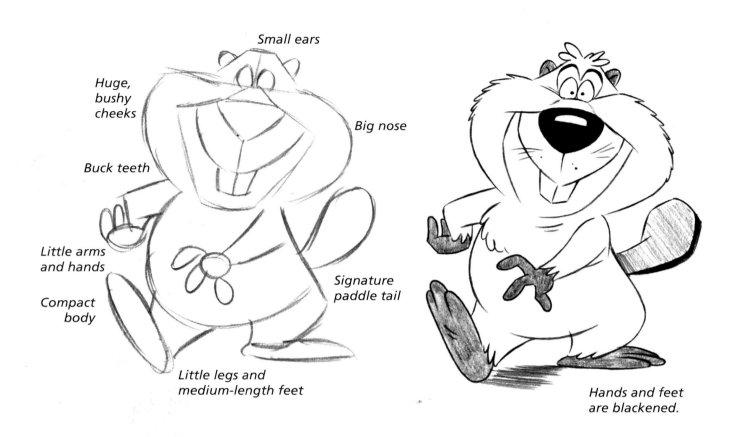

Small ears

Huge, bushy cheeks

Big nose

Buck teeth

Little arms and hands

Compact body

Signature paddle tail

Little legs and medium-length feet

Hands and feet are blackened.

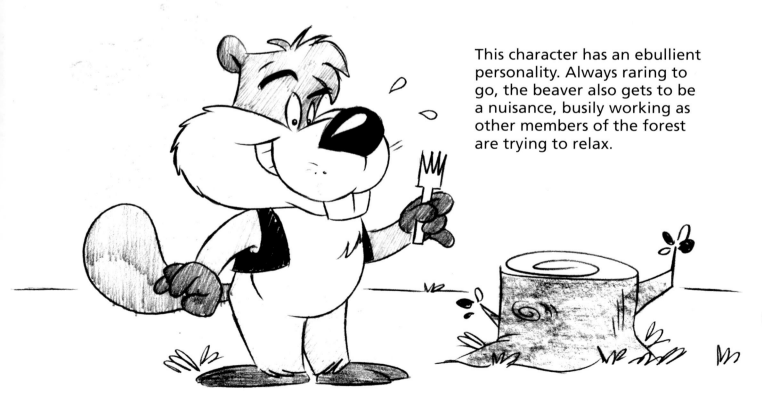

This character has an ebullient personality. Always raring to go, the beaver also gets to be a nuisance, busily working as other members of the forest are trying to relax.

THE BARNYARD COW

No farm scene is complete without a good-natured cow lumbering about. This animal has a heavy head constructed like a horse's, only shorter. Even though the cow is a female, don't overdo the eye-lashes or lips —your audience will assume she's feminine. Her personality can be dumb, goofy, or sweet— she's not usually depicted as a wise-guy or bully.

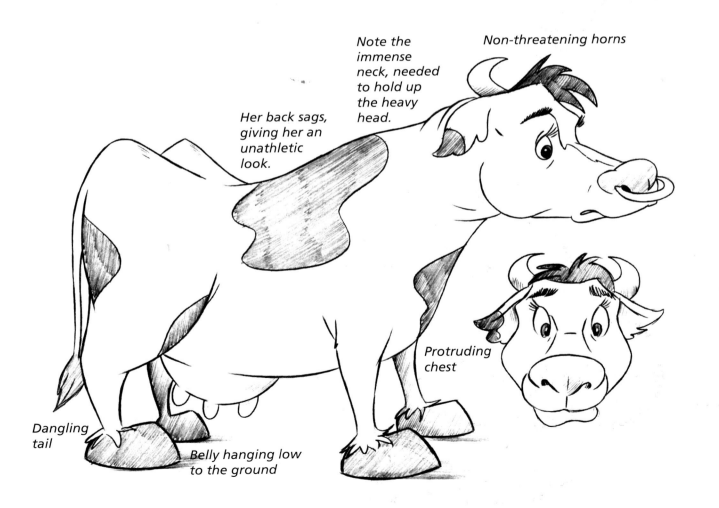

Note the immense neck, needed to hold up the heavy head.

Non-threatening horns

Her back sags, giving her an unathletic look.

Protruding chest

Dangling tail

Belly hanging low to the ground

OUR LAST ACT TOGETHER

HUMAN-ANIMAL INTERACTION

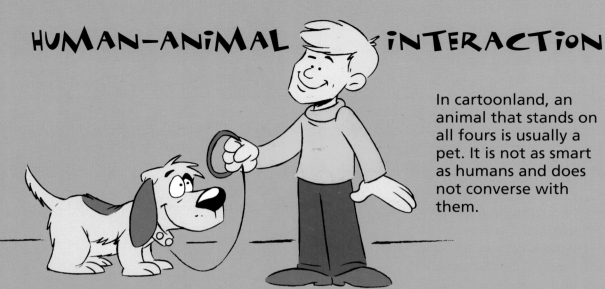

In cartoonland, an animal that stands on all fours is usually a pet. It is not as smart as humans and does not converse with them.

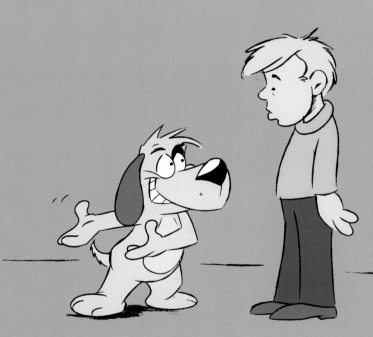

However, an animal that stands on two legs is often superior in intelligence to its human master. This character will often reply to a human in a thought balloon. In animation, animals frequently talk to humans. Here, the animal has the upper hand.

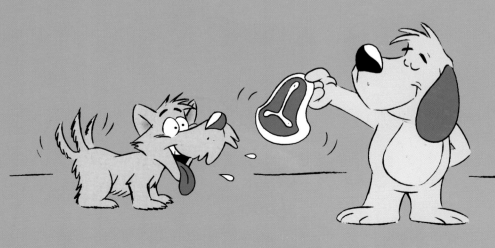

A dog that stands on two legs can have its own pet, who stands on four legs. The four-legged pet is usually mute.

BABY ANIMALS

Animal babies are as cute as human babies. Use the same traits to give cuteness to any baby character.

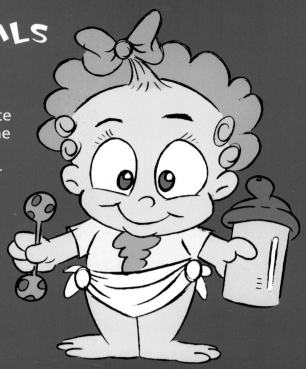

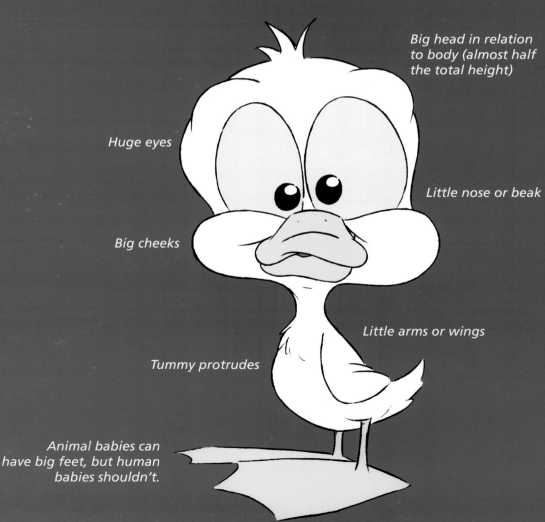

Big head in relation to body (almost half the total height)

Huge eyes

Little nose or beak

Big cheeks

Little arms or wings

Tummy protrudes

Animal babies can have big feet, but human babies shouldn't.

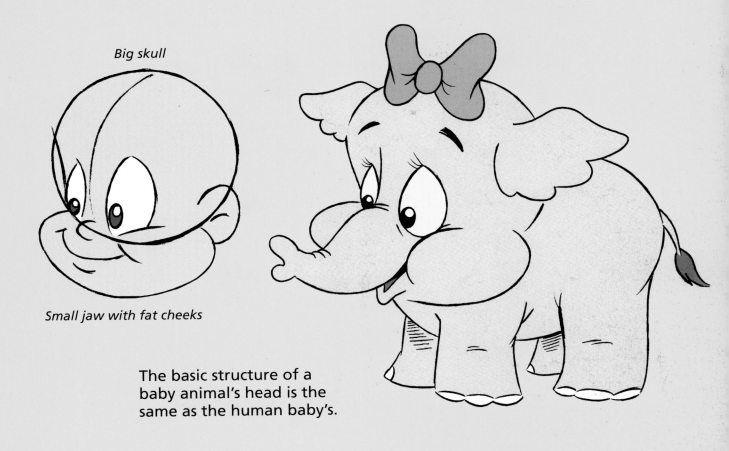

Big skull

Small jaw with fat cheeks

The basic structure of a baby animal's head is the same as the human baby's.

PLACEMENT OF THE EYES

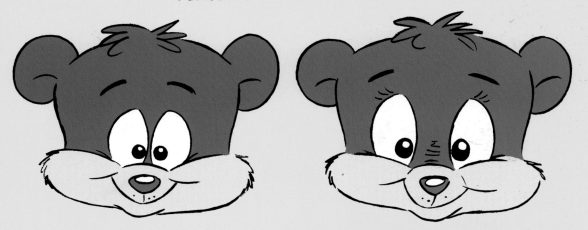

The wider apart the eyes are placed, the sweeter and more infant-like the character will appear. Larger pupils also add to a younger look.

FeMaLe aniMals

Three elements are important to giving a cartoon animal a distinctly female identity: makeup, hair and, clothes.

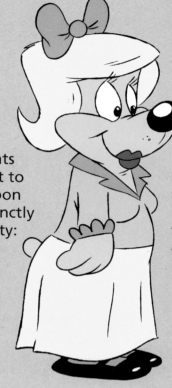

Not all women wear skirts, but to convey femininity at a glance, we deal in stereotypes.

YOUNGER FEMALE
Add contemporary hairstyle and accessories.

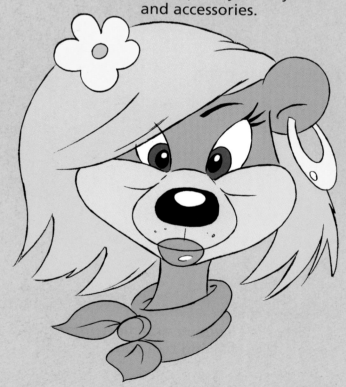

THE FEMALE EYE

Start with a teardrop shape, tilted to the side.

Add a shiny pupil and add the iris.

Color in and add thick mascara to eyelashes.

CARTOON WARDROBE

These are all standard fare for cartoon animals.

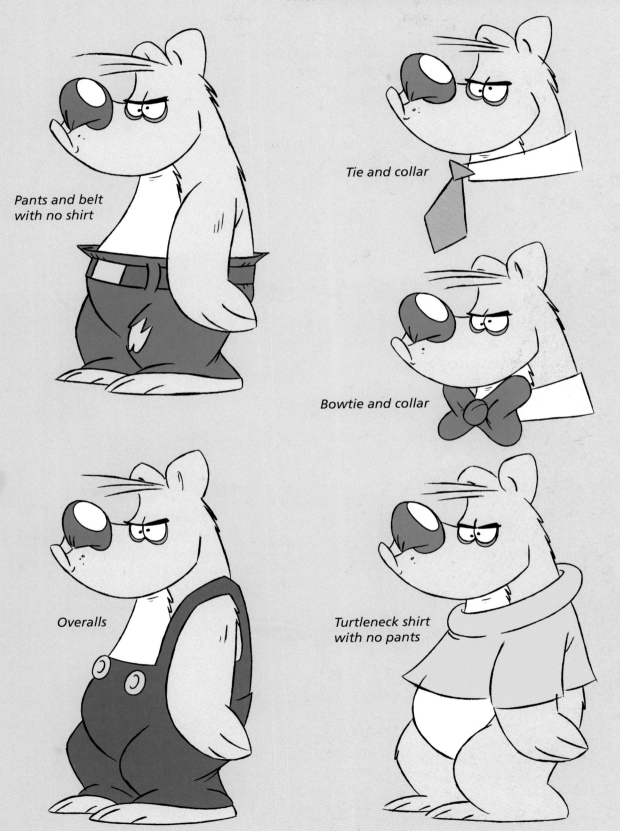

Pants and belt with no shirt

Tie and collar

Bowtie and collar

Overalls

Turtleneck shirt with no pants

IDENTIFYING COSTUMES

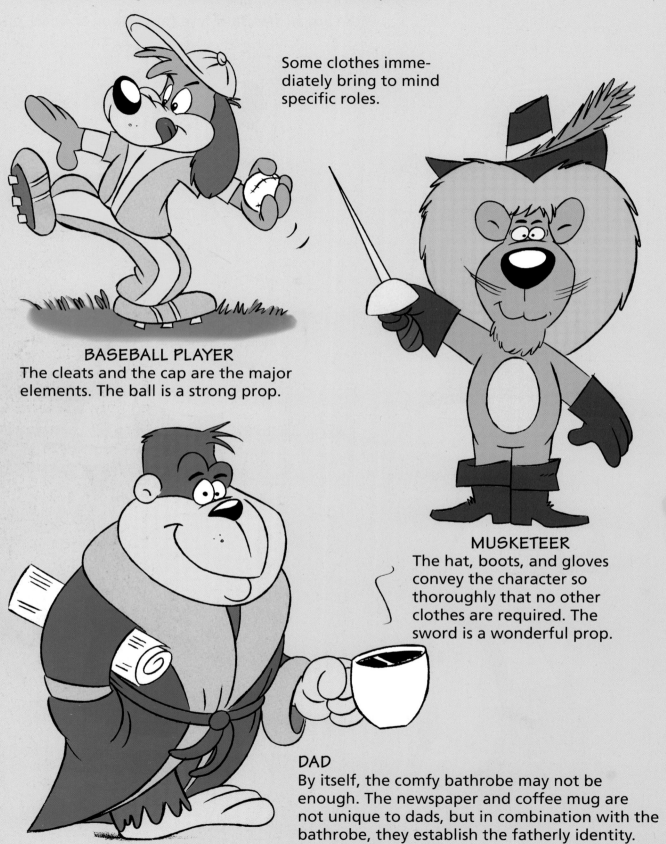

Some clothes immediately bring to mind specific roles.

BASEBALL PLAYER
The cleats and the cap are the major elements. The ball is a strong prop.

MUSKETEER
The hat, boots, and gloves convey the character so thoroughly that no other clothes are required. The sword is a wonderful prop.

DAD
By itself, the comfy bathrobe may not be enough. The newspaper and coffee mug are not unique to dads, but in combination with the bathrobe, they establish the fatherly identity.

A HAT FOR EVERY HEAD

If your character's ears and hat are large enough, you can poke the ears through the hat's brim.

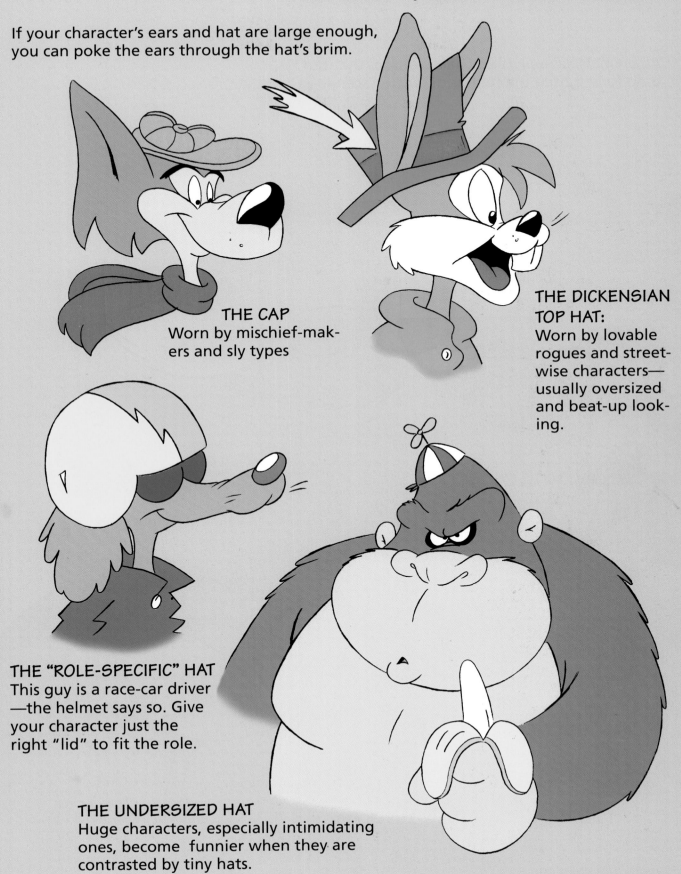

THE CAP
Worn by mischief-makers and sly types

THE DICKENSIAN TOP HAT:
Worn by lovable rogues and street-wise characters—usually oversized and beat-up looking.

THE "ROLE-SPECIFIC" HAT
This guy is a race-car driver—the helmet says so. Give your character just the right "lid" to fit the role.

THE UNDERSIZED HAT
Huge characters, especially intimidating ones, become funnier when they are contrasted by tiny hats.

CARTOON ANIMAL HUMOR

All animals have physical characteristics that can be used to heighten the humor of a given scene.

These cat's claws make great grabbers.

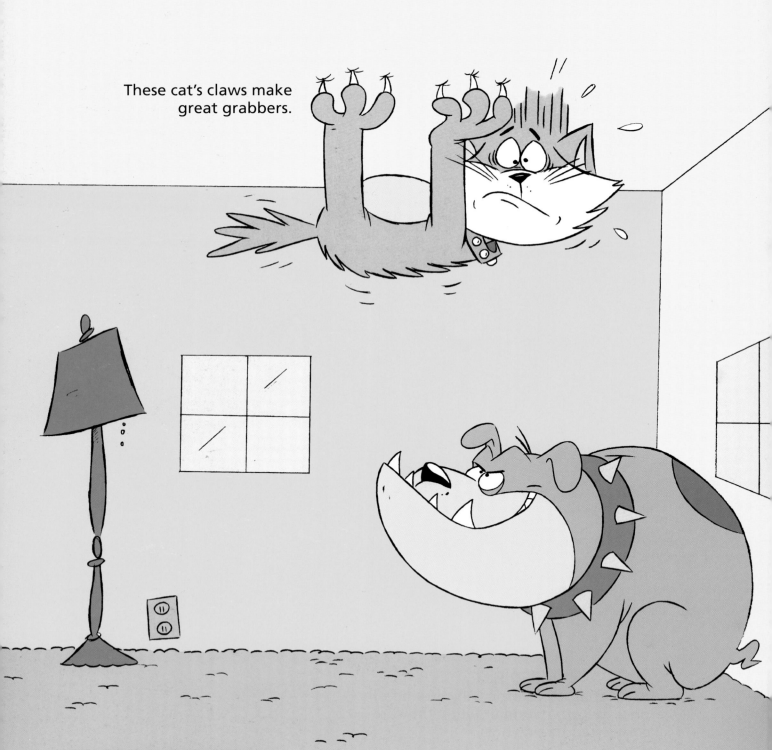

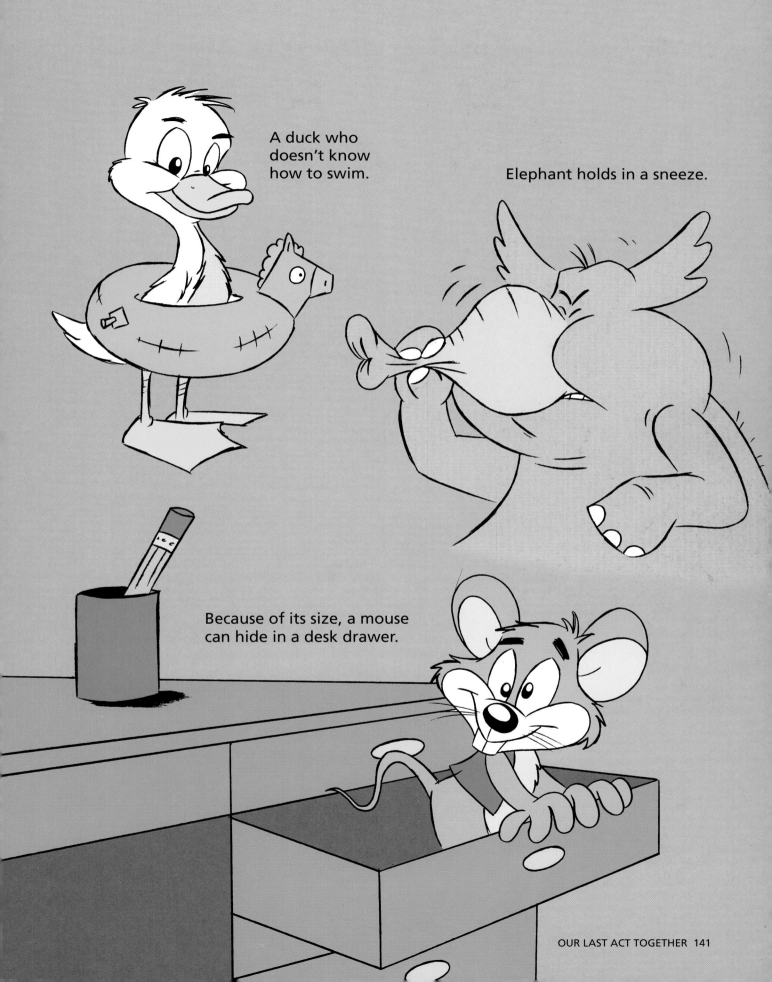

A duck who doesn't know how to swim.

Elephant holds in a sneeze.

Because of its size, a mouse can hide in a desk drawer.

HUGE HUMANS WITH SMALL ANIMALS

Animals and humans in cartoons intermingle more closely than in real life. Sometimes the animals are used as props, incidental to a scene, but they can still add humor if you try enlarging the human and shrinking the animal. Here the sizes are way out of proportion and the results are a good bit of fun.

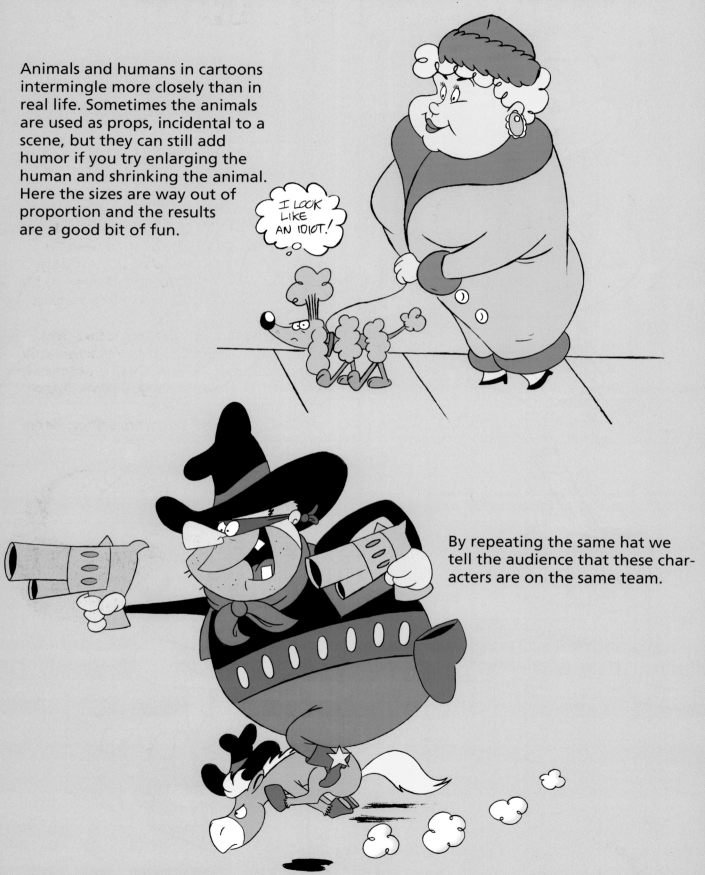

I LOOK LIKE AN IDIOT!

By repeating the same hat we tell the audience that these characters are on the same team.

IN CLOSING...

We've come to the end of this book together. But it's never really the end as long as there's a pencil in your hand and a piece of paper somewhere to be found. We are now, rather, at the starting point.

You may invent an animal cartoon that becomes the star of the next great comic strip or animated film. Someone's got to do it. Why not you?

The thing that creates good cartoonists is time spent drawing. In drawing, you experiment. You develop your own style and a cartoonist's eye, and no book can give you that. What a book can do, I hope this one has done: open up new possibilities, take you past the sticking points, answer questions that need to be answered, and perhaps most important of all, inspire you.

The joy that your cartoon characters exude can't be faked. They come directly from your imagination. That is ultimately the most powerful tool you have. Keep it nourished.

Until we meet again, remember: *Keep drawing!*

INDEX